Leonardo da Vinci

*These and other titles are included in The
Importance Of biography series:*

Alexander the Great
Muhammad Ali
Maya Angelou
Louis Armstrong
James Baldwin
Clara Barton
The Beatles
Alexander Graham Bell
Napoleon Bonaparte
Julius Caesar
Rachel Carson
Charlie Chaplin
Charlemagne
Cesar Chavez
Chief Joseph
Winston Churchill
Cleopatra
Christopher Columbus
Hernando Cortes
Marie Curie
Leonardo da Vinci
Charles Dickens
Emily Dickinson
Walt Disney
Amelia Earhart
Thomas Edison
Albert Einstein
Duke Ellington
F. Scott Fitzgerald
Dian Fossey
Anne Frank
Benjamin Franklin
Galileo Galilei
Emma Goldman
Jane Goodall
Martha Graham
Lorraine Hansberry
Stephen Hawking
Ernest Hemingway

Jim Henson
Adolf Hitler
Harry Houdini
Thomas Jefferson
Mother Jones
John F. Kennedy
Martin Luther King Jr.
Joe Louis
Douglas MacArthur
Malcolm X
Thurgood Marshall
Margaret Mead
Golda Meir
Michelangelo
Mother Teresa
Wolfgang Amadeus
 Mozart
John Muir
Sir Isaac Newton
Richard M. Nixon
Georgia O'Keeffe
Louis Pasteur
Pablo Picasso
Elvis Presley
Queen Victoria
Jackie Robinson
Norman Rockwell
Eleanor Roosevelt
Anwar Sadat
Margaret Sanger
Oskar Schindler
William Shakespeare
John Steinbeck
Tecumseh
Jim Thorpe
Mark Twain
Pancho Villa
H. G. Wells
Simon Wiesenthal

THE IMPORTANCE OF

Leonardo da Vinci

by Stuart A. Kallen and P. M. Boekhoff

Lucent Books, P.O. Box 289011, San Diego, CA 92198-9011

Library of Congress Cataloging-in-Publication Data

Kallen, Stuart A. 1955–
 Leonardo da Vinci / by Stuart A. Kallen and P. M.
Boekhoff
 p. cm.—(The importance of)
 Includes bibliographical references and index.
 Summary: A biography of the well-known Italian Ren-
naissance man, discussing his personal life, artistic accom-
plishments, scientific observations, and final legacy.
 ISBN 1-56006-604-0 (lib. : alk. paper)
 1. Leonardo, da Vinci, 1452–1519—Juvenile literature.
 2. Artists—Italy—Biography—Juvenile literature. [1.
Leonardo, da Vinci, 1452–1519. 2. Artists] I. Boekhoff, Patti
M., 1957– II. Title. III. Series.

N6923.L33 K35'2000
709.2—dc21
[B] 99-049097

Contents

Foreword

THE IMPORTANCE OF biography series deals with individuals who have made a unique contribution to history. The editors of the series have deliberately chosen to cast a wide net and include people from all fields of endeavor. Individuals from politics, music, art, literature, philosophy, science, sports, and religion are all represented. In addition, the editors did not restrict the series to individuals whose accomplishments have helped change the course of history. Of necessity, this criterion would have eliminated many whose contribution was great, though limited. Charles Darwin, for example, was responsible for radically altering the scientific view of the natural history of the world. His achievements continue to impact the study of science today. Others, such as Chief Joseph of the Nez Percé, played a pivotal role in the history of their own people. While Joseph's influence does not extend much beyond the Nez Percé, his nonviolent resistance to white expansion and his continuing role in protecting his tribe and his homeland remain an inspiration to all.

These biographies are more than factual chronicles. Each volume attempts to emphasize an individual's contributions both in his or her own time and for posterity. For example, the voyages of Christopher Columbus opened the way to European colonization of the New World. Unquestionably, his encounter with the New World brought monumental changes to both Europe and the Americas in his day. Today, however, the broader impact of Columbus's voyages is being critically scrutinized. *Christopher Columbus,* as well as every biography in The Importance Of series, includes and evaluates the most recent scholarship available on each subject.

Each author includes a wide variety of primary and secondary source quotations to document and substantiate his or her work. All quotes are footnoted to show readers exactly how and where biographers derive their information, as well as provide stepping stones to further research. These quotations enliven the text by giving readers eyewitness views of the life and times of each individual covered in The Importance Of series.

Finally, each volume is enhanced by photographs, bibliographies, chronologies, and comprehensive indexes. For both the casual reader and the student engaged in research, The Importance Of biographies will be a fascinating adventure into the lives of people who have helped shape humanity's past and present, and who will continue to shape its future.

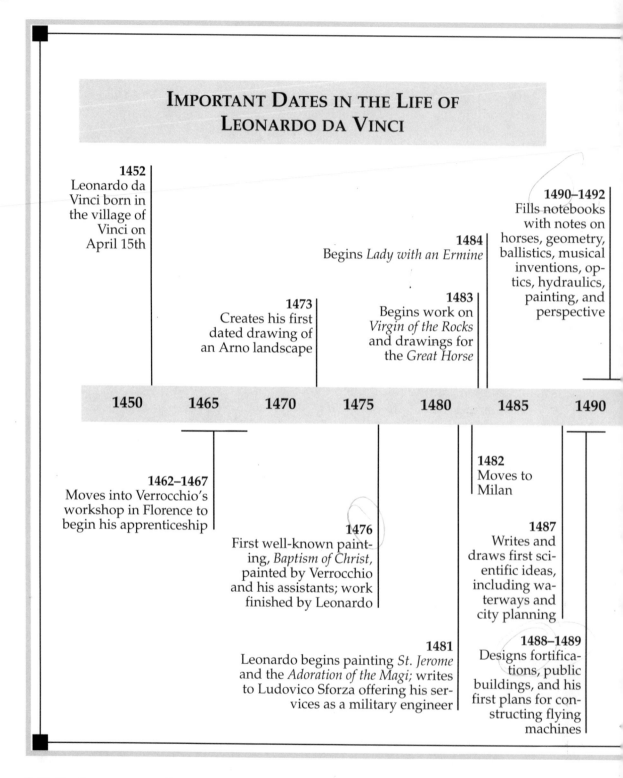

IMPORTANT DATES IN THE LIFE OF LEONARDO DA VINCI

1452
Leonardo da Vinci born in the village of Vinci on April 15th

1473
Creates his first dated drawing of an Arno landscape

1484
Begins *Lady with an Ermine*

1483
Begins work on *Virgin of the Rocks* and drawings for the *Great Horse*

1490–1492
Fills notebooks with notes on horses, geometry, ballistics, musical inventions, optics, hydraulics, painting, and perspective

1450 **1465** **1470** **1475** **1480** **1485** **1490**

1462–1467
Moves into Verrocchio's workshop in Florence to begin his apprenticeship

1476
First well-known painting, *Baptism of Christ*, painted by Verrocchio and his assistants; work finished by Leonardo

1482
Moves to Milan

1487
Writes and draws first scientific ideas, including waterways and city planning

1481
Leonardo begins painting *St. Jerome* and the *Adoration of the Magi;* writes to Ludovico Sforza offering his services as a military engineer

1488–1489
Designs fortifications, public buildings, and his first plans for constructing flying machines

[14]93
[c]lay model for the
[Gr]eat Horse fin-
[is]hed and dis-
[pl]ayed; Leonardo
[be]comes famous
[th]roughout Italy

1502
Leonardo works for
Cesare Borgia as a
military engineer

1519
Leonardo da
Vinci dies
May 2

1504
Ser Piero, Leonardo's father, dies, leav-
ing no will; Leonardo begins *Mona
Lisa*; fills notebooks with maps, notes
on birds, and geometry

1516
Goes to
France at
the request
of King
François I

1497
The *Last
Supper*
completed

1506
Leonardo lives in Milan but
returns often to Florence to
argue a lawsuit against his
half-brothers over inheri-
tance from father and uncle;
begins what later becomes
Codex Leicester, a detailed
study of water

[14]95 **1500** **1505** **1510** **1515** **1520**

1499
Milan surren-
ders to French
invaders;
Leonardo
leaves
for Venice

1503
Returns to Flo-
rence; advises on
building canals
along the Arno
River; studies ge-
ology; begins
work on *Battle of
Anghiari*

1507–1508
Begins dissec-
tions of humans
in Florence hos-
pital while
making hun-
dreds of
anatomical
drawings of the
human body

1514
Studies chemistry,
solar energy, con-
cave mirrors, and
the heart; makes
plans to drain the
Pontine marshes;
draws the *Deluge*;
begins to exhibit
signs of failing
health; paints *St.
John the Baptist*

1495
Begins work on the *Last
Supper* for the Domini-
can monastery of Santa
Maria delle Grazie

1513
Leaves Milan for Rome with
Francesco Melzi; writes about
painting landscapes, botany,
and the flight of birds

Artist, Inventor, Legend

In the late 1400s, Italy experienced a great flowering of European culture in art, music, and literature known as the Renaissance, a word that means "rebirth." This brilliant period of artistic achievement is remembered as the age of painters such as Raphael, Titian, Michelangelo—and especially—Leonardo da Vinci. For Leonardo was a legend in his own lifetime, and his paintings such as *Mona Lisa* and the *Last Supper* have secured his reputation as one of the world's greatest artists in the nearly five centuries since his death in 1519.

Leonardo da Vinci was born in an obscure hamlet in Italy and lived in a time of constant war. But by taking advantage of his towering intelligence, Robert Payne writes that Leonardo:

> opened up vast areas of human knowledge and painted so superbly that for many people he represents the single "universal genius," the prototype of Western man in his utmost accomplishment, Renaissance man in his utmost splendor.[1]

Leonardo painted, sculpted, designed buildings, and taught himself to play music. His mind never stopped in its quest for innovation and knowledge. He recorded his discoveries on thousands of manuscript pages that were filled with

Leonardo's Vitruvian Man *is one of the most well known of his numerous sketches of the human body.*

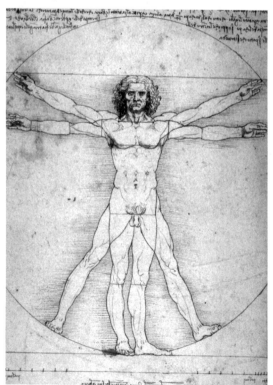

observations about human nature, studies of anatomy, and reflections on astronomy, zoology, topography, and physical geography. In addition to writing about art and science, he penned mythical tales, comedic fables, and entertaining observations about life, love, and occasionally, even himself.

As an inventor, Leonardo designed gadgets, tools, machines and other inventions that—in some cases—were centuries ahead of their time. In this role, Leonardo acted as an engineer, architect, geologist, mathematician, military consultant and adviser to heads of state, army commanders, and aristocrats.

The dozens of notebooks, or codices, that Leonardo left behind were filled with writings, sketches, formulas, experiments, and contemplations on hundreds of subjects. The artist, however, rarely wrote down personal information or his innermost thoughts. As a result, historians have had to piece together his biography from legal documents, receipts, and—of course—the paintings he left behind. This means that exact dates of events, and Leonardo's age when certain affairs took place, remain sketchy. It is even unknown, for example, exactly what year Leonardo painted the *Mona Lisa*. And according to art historian Roy McMullen, who has studied the painting's history extensively, the *Mona Lisa* is the most famous work in the forty-thousand-year history of the visual arts: "It provokes instant shocks of recognition on every continent from Asia to America [and] sells as many postcards as a tropical resort."[2]

The High Renaissance

The sixty-seven years that Leonardo was alive were some of the most turbulent and creative in European history. The events of that time helped set the stage for the modern world. During his lifetime Leonardo saw the development of the printing press, the European discovery of America, and a burst of creativity so astounding it is still remembered today as the High Renaissance. One of the centers of the Italian Renaissance was the city of Florence—only twenty miles from Leonardo's hometown of Vinci—where generous patrons gathered gifted circles of artists and musicians around them.

The Cathedral of Florence, completed in 1436, contains the work of many Renaissance artists, who assisted with both the design of the structure and the interior art.

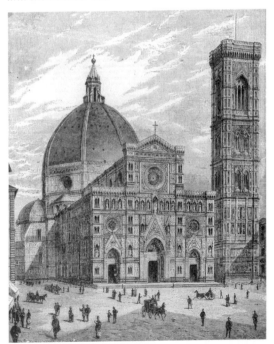

According to Ladislao Reti, editor of *The Unknown Leonardo:*

> The Renaissance was the rebirth of man out of the dark years of medieval superstition and belief and a return to the light of human reason. Italy and particularly Florence were at the heart of this reawakening of the human spirit—what more promising time or place could have existed as Leonardo's milieu?[3]

The Renaissance, to which Leonardo was born, was marked by a cultural and intellectual movement that emphasized the personal worth of the individual and the central importance of human values and scientific knowledge. This belief, called humanism, was the driving force behind the rediscovery and study of the literature, art, and civilization of ancient Greece and Rome. Although the Renaissance humanists were often devout Christians, they opposed blind acceptance of church authority and promoted secular studies even when the results conflicted with religious teachings.

The pagan mythology of pre-Christian Greece and Italy enriched the subject matter available to Renaissance artists, who had previously been restricted to the depiction of Christian religious stories. The medieval belief in the power of religious faith had been transformed into the humanist belief in the power of individuals.

The rise of humanism allowed Leonardo to expand his genius beyond what would have been allowed in an earlier time. He was able to break with the artistic traditions of the Middle Ages and paint nonreligious topics, and combine themes from the ancient and modern worlds.

Though most famous as a painter, Leonardo was also an avid sculptor, musician, architect, engineer, inventor, scientist, and writer. Due to his numerous talents, later generations deemed him the quintessential "Renaissance man."

SCIENTIFIC DISCOVERIES

The Renaissance was a time of scientific discovery unmatched in previous European history. It provided a rich environment for Leonardo to study, invent, and design. Johannes Gutenberg invented the printing press, which opened the fields of literature, science, art, and philosophy to educated men and women. The methods of fighting wars were drastically altered with the increased usage of cannons and gunpowder. The invention of the mariner's compass made possible the voyages of Christopher Columbus and

expanded European horizons. Leonardo's discoveries foreshadowed the discoveries of the astronomer Copernicus, who proved that instead of the sun and planets revolving around the earth, the earth revolved around the sun. This, according to Reti, "changed man's perspective of himself and his world in relation to the universe."[4]

By the late fifteenth century, Leonardo was poised between the classic arts of antiquity and the new challenges of social, economic, scientific, and religious developments.

The world was ready for an artist who could go beyond art, a scientist whose curiosity accepted no limitations, a man who could go from the ancient world to the modern one. Leonardo was both the product of his times, artist, scientist, inventor, sculptor, engineer, musician, writer, technologist—and more—and the shaper of his times as well as our own. From the Renaissance to the twentieth century, the work of Leonardo transcends time.[5]

1 The Young Artist

The sleepy little village of Vinci was about a day's journey on horseback from the bustling city of Florence. Like hundreds of other small communities in Italy in the fifteenth century, Vinci was dominated by a small castle and a church. A boy born in such a village could expect to spend his entire life there.

On April 15, 1452, Leonardo (also known sometimes as Lionardo) was born in a home on the slopes of Monte Albano, above the village of Vinci. Unlike many other historical figures, the exact birth date of Leonardo is well known because his eighty-year-old grandfather, Antonio da Vinci, wrote a legal document attesting to that fact. Although its brownish ink has faded, the document has survived among the state documents of Florence. With a firm, experienced hand, the boy's grandfather wrote:

> A grandson of mine was born, son of Ser Piero, my son, on April 15, Saturday at three in the night [i.e., at 11 P.M.]. He was named Lionardo. He was baptized by the priest Piero di Bartolomeo [in the presence of ten witnesses].[6]

Antonio was descended from a long line of notaries, although he was not a no-

tary himself. The purpose of the legal document was to affirm that although Leonardo was born out of wedlock (his parents were not married) the baby had been accepted into his father's family. Leonardo was baptized at that time, which also added respectability to his circumstances. He would henceforth be known as Leonardo di Ser Piero da Vinci.

Antonio deliberately excluded the name of Leonardo's mother from the birth document. As Robert Payne writes:

> We know very little about her because the information was deliberately suppressed. The *Anonimo Gaddiano*, an anonymous compilation of short biographies of famous Florentines . . . describes Leonardo's mother as a woman *nata di buon sangue*, born of good blood, which meant and could only mean that she was of noble birth. The *Anonimo Gaddiano* was compiled at a time when there were many people still living who knew the name of the girl's family and could, if they had wanted to, have divulged the name to anyone inquiring into Leonardo's ancestry. For perfectly intelligible reasons

THE VILLAGE OF VINCI

The town of Vinci remains today much as it was in Leonardo's day. Built high on the mountain slope above the Arno River Valley, the town is made up of about a dozen stone houses with red tile roofs, built together within the protection of the battlement walls of an ancient castle. The countryside below stretches for miles in a fertile pattern of farm fields, grapevines, and fruit trees. Some of the ancient silver-green olive trees were alive in Leonardo's lifetime. The fields are split by the Arno River, which flows past Florence, westward to Pisa and finally to the sea. In The World of Leonardo da Vinci, *author Ivor B. Hart discusses the effect the natural world around Vinci might have had on the young Leonardo.*

"The village of Vinci was ideally and beautifully set for [the] development [of Leonardo's] innate love of nature. Dominated by Monte Albano and (to his child mind) a seemingly mysterious but fascinating series of crags, slopes and mountain streams on the one side, and the rich green valley of Lucca on the other, his imagination and his interest were continually aroused, and, without doubt, the seed was sown for that perpetual urge to a study of nature and natural phenomena that was to endure throughout his lifetime."

A modern photo of Vinci, Italy, Leonardo's birthplace and hometown. The bell tower of the church where Leonardo was christened is still visible.

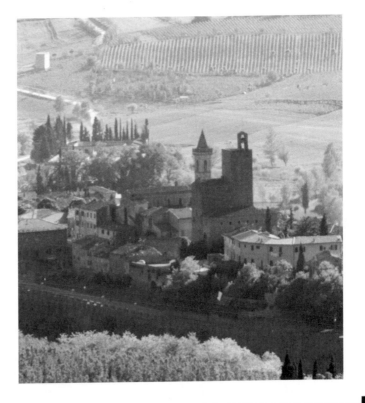

they chose not to divulge it: in this way they protected the girl's honor and her family name, and they made it more possible for her to find a husband later, since Ser Piero refused to marry her.

We know from other documents that her name was Caterina, but this is all we know. . . . [We] have no idea where she came from, or how old she was, or what she looked like. . . . Everything we know about [Leonardo's father] leads us to believe that the reason he did not marry Caterina was because her family could not offer a sufficiently large dowry. It was an age when men demanded large dowries.[7]

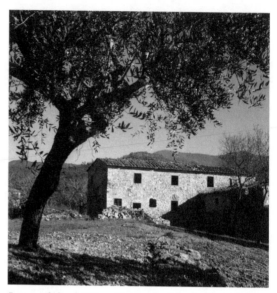

Leonardo's childhood home in Vinci. Though his mother and father were not married, Leonardo was accepted by both of his parents' families.

FAMILY INFLUENCES

Leonardo was the only child in his grandfather's house. His family circle included his grandfather Antonio and grandmother Mona Lucia and their adult children, Leonardo's uncle Francesco and aunt Violante, the younger brother and sister of Ser Piero.

Leonardo's grandfather had broken the tradition of three generations of notaries (lawyers) before him. Instead of becoming a notary he had returned to the small estate of his forefathers in Vinci, renting the land out to farmers, and living a quiet life as a landowner. He married late in life, and he was over fifty when his first child, Ser Piero, was born. As biographer Serge Bramly observed: "For a couple as elderly as Antonio and [Mona] Lucia, the arrival of a first grandson, even illegitimate . . .

would have been a happy event: a child to enliven their declining years."[8]

The young Leonardo spent a lot of time with his uncle Francesco, who managed estates in and around Vinci. Francesco had no children of his own and was always close to Leonardo.

Only sixteen years older than his nephew, Francesco took his pleasure from the land, from which he was never long away. When Antonio was no longer able to go out in the fields, it was Francesco who would have supervised the olive harvest, inspected the grapevines, and negotiated with sharecroppers. [Leonardo] would have grown up alongside this gentle and contemplative man of independent character, who surely knew the names and qualities of plants [the region is

rich in medicinal herbs], the signs of bad weather, the habits of the wild creatures, and the superstitious legends that govern country people's acts. Leonardo would have acquired in his company a love of the outdoors and a curiosity about the natural world. Francesco planted mulberry trees and dabbled in silk production; was it for his benefit that Leonardo later devised a mill for crushing dyestuffs? The close bond between them does not seem to have slackened with time. When Francesco died childless in 1506, it was to Leonardo and not to his legitimate nephews that, contrary to custom, he left his possessions.[9]

Francesco was not young Leonardo's only male influence. He acquired a stepfather at an early age, for his mother Caterina married a man named Antonio Achattabrigha. Leonardo was always welcome in his mother's house in Vinci, and as a child he was exposed to the pottery kilns built by Achattabrigha.

As he grew older, Leonardo learned to make sculptures from ceramic clay and fire them in kilns. He also worked in relief, the art of sculpting raised figures on a flat piece of clay. To make a relief Leonardo used his skills of drawing and sculpture. This was his favorite medium when he was very young. Throughout his life Leonardo enjoyed making sculptures in terra-cotta. His later art is thought to have been inspired by ancient relief images, especially images of horses, for which he professed a lifelong fondness. In addition, Leonardo was a lover of nature and created many remarkable early drawings of the natural beauty surrounding Vinci.

LEARNING LATIN, MATH, AND MUSIC

The year Leonardo was born, Ser Piero, his father, married a woman named Albiera di Giovanni Amadori, who was a young heiress from a wealthy Florentine family. Leonardo had lived with his mother for his first five years, then was adopted by Ser Piero and taken into his grandfather's household in nearby Vinci. Ser Piero was often away from the Vinci estate on business in Florence.

As Leonardo grew up in Vinci, he worshiped in the village church, learned the local songs, and lived a life similar to every other boy in his town. In school, Leonardo's education was typical of the time. In addition to reading and writing, he learned basic mathematics and Latin grammar.

Lessons in Latin grammar followed the ancient Greek pattern of learning: The students listened closely and followed commands to the letter, to avoid being beaten by the *grammatist,* or teacher. According to author Richard W. Hibler,

> the *grammatist* was an authoritarian who commanded absolute attention and punished students for the slightest offense. Some teachers were tyrannical brutes who terrorized the young boys, giving severe punishment for the slightest offense.[10]

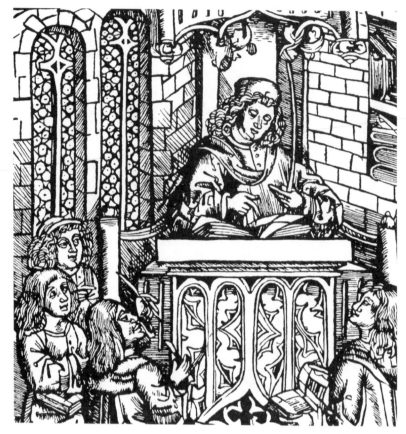

In this Renaissance illustration, students listen with rapt attention as their teacher lectures. Teachers demanded strict discipline and severely punished students who did not follow directions.

Throughout the ancient world, *grammatists* were harsh disciplinarians who routinely raised welts on young learners by beating them with sticks and straps.

Leonardo shrank from this sort of teaching, and as a result did not do well in Latin. He was, however, brilliant in math. After he had barely begun his studies he could solve so many problems and puzzles that his teachers were amazed. And some of his eager questions were more than his teachers could answer. He continually raised difficult questions and doubts, never seemed satisfied, and was always seeking more knowledge.

Leonardo's musical talent had also become obvious by this time, and the boy began to improvise his own songs, sing, and play several instruments proficiently, particularly the lute.

SKIPPING SCHOOL

School was not Leonardo's favorite place. He did not like the rough play of the other boys, or the monotony of rote learning. Many days he would skip school and escape to the rocky, steep terrain around Vinci, where the air was fresh and sweet and the wild creatures he loved were in abundance. Leonardo preferred to lie per-

fectly still and observe the activities of insects and lizards. Above all, he loved birds, marveling at their powers of flight and pondering the forces that allowed them to glide through the air.

Later in life, Leonardo wrote about the life of a young artist who rejected his childhood companions to spend his days alone, observing nature:

> A painter needs . . . the absence of all companions who are alienated from his studies; his brain must be easily impressed by the variety of objects, which successively come before him, and also free from other cares. . . . And above all he must keep his mind as clear as the surface of a mirror, which assumes colours as various as those of the different objects. And his companions should be like him as to their studies, and if such cannot be found he should keep his speculations to himself alone, so that at last he will find no more useful company [than his own].[11]

THE POWER OF SER PIERO

In 1464, when Leonardo was twelve, his stepmother died during childbirth. Ser Piero, thirty-six, set out immediately in search of another wife and heiress. The

A field of wild poppies in an olive grove near Vinci. The natural beauty around his hometown intrigued young Leonardo, who spent much of his time observing the native insects and animals.

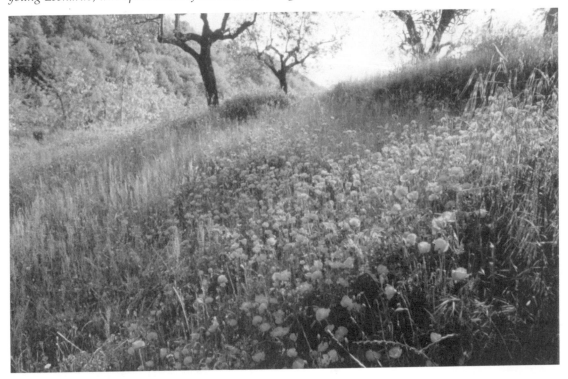

A merchant weighs fabric in this illuminated initial from the Manuscript of the Guild of Wool Merchants. *The wool guild was one of the most influential in Florence.*

following year he married Francesca di ser Giuliano Landfredini, who was sixteen.

Ser Piero was an ambitious man, and his new wife had family connections that proved to be extremely useful for his notary career. Ser Piero moved to a nice home in Florence. Leonardo spent some of his time in Florence, often returning to Vinci, an easy day's journey on horseback.

Ser Piero was now a man of prominence and wealth, with a large practice. He worked close to the seat of power in Florence. He specialized in the legal and financial affairs of churches, abbeys, and convents, and he also possessed a private practice that was equally successful. He was the legal adviser and agent of the Abbey of the Benedictines, one of the oldest foundations in Florence. Ser Piero was also notary for the Guild of Merchants, the most powerful of the seven guilds run by the professional people of Florence.

The guilds were like trade unions and represented some of the most influential political forces in Florence. They not only regulated their respective trades but owned property, lent money, and even had representatives abroad. They established charitable institutions and oversaw various duties, such as church restoration and civic projects.

Although the legal documents drawn up by Ser Piero are dry and technical, they shed some light on the life of the man. As was required by the legal profession, Ser Piero knew Latin extremely well. He was a clear-headed businessman and strongly motivated by a desire for monetary gain. He fought hard for his clients and they were totally dependent on him.

Ser Piero was also a political man who was on equally good terms with the guilds and the three religious orders that ran Florence—the Franciscans, the Dominicans, and the Benedictines. Those religious orders were in constant opposition to each other and often forced abrupt changes in government, but Ser Piero was able to use the disputes to his advantage, and he grew richer and more influential every year.

In 1475, Francesca died and Ser Piero was married for a third time, to Marguerita di Jacopo di Guglielmo, seventeen. Up until this time, Leonardo was Ser Piero's only child. But his union with Marguerita was

fruitful, and within ten years Ser Piero was father to four more sons and two daughters. Later, he would marry again to a woman who would bear him one daughter and five sons, the last son being born when Ser Piero was in his seventies and Leonardo was in his early fifties.

SER PIERO VISITS THE MASTER ARTIST

Because Leonardo was born out of wedlock, many of the opportunities normally available to the sons of wealthy men were closed to him. He could not become a member of a major guild, and he could not attend the local university. Other than artist, the only careers open to the young man were soldier or priest, neither of which suited his talents. Even the powerful Ser Piero could not overcome these obstacles, so instead, he took several of Leonardo's early drawings to the studio of the master artist Andrea del Verrocchio. Ser Piero hoped that through Verrocchio, Leonardo could gain membership to the minor guild of painters called the guild of St. Luke.

Verrocchio, born in 1435, was a goldsmith, wood carver, painter, musician, student of mathematics, and, for a time, the greatest sculptor in Florence. In his workshop, Verrocchio took on all sorts of assignments for guilds, religious organizations, and individuals. The artist and his apprentices produced sculptures, paintings, musical instruments, and other objects of art.

In his 1893 book *The Renaissance,* author Walter Pater described Verrocchio's studio:

Beautiful objects lay about there—reliquaries, pyxes, silver images for the pope's chapel at Rome, strange fancy-work of the middle age, keeping odd company with fragments of antiquity, then but lately discovered. . . . Verrocchio was an artist of the earlier Florentine type, carver, painter, and worker in metals, in one; designer, not of pictures only, but of all things for sacred or household use, drinking vessels, ambries, instruments of music, making them all fair to look upon, filling the common ways of life with the reflexion of some far-off brightness; and the years of patience had refined his hand till his work was now sought after from distant places.[12]

Verrocchio was amazed when he saw Leonardo's remarkable early works and excitedly assured Ser Piero that the young man was born to be an artist.

LEARNING FROM VERROCCHIO

Historians estimate that Leonardo was between twelve and seventeen years old when he was taken in by Verrocchio.

As a student in the master's studio, Leonardo would have learned how to work in various artistic mediums, grind pigments, and mix colors. The standard medium for painting was egg tempera in which egg yolks, acting as a binder, were mixed with finely ground pigments. The student would also prepare wooden panels for painting with a fine plaster called

gesso, and learn to build up layers of paint to finish a composition. In addition, it was necessary for a young man (women were not permitted in institutions of learning) to learn how to do interpretations of various religious icons such as saints and biblical figures. Since humanism was also in style, painters needed a working knowledge of classical subjects like the mythical gods and heroes of ancient Greece and Rome.

While learning these and the other skills of a painter, Leonardo also spent many hours in the master's studio sculpting with wood and clay. He was taught by the shop's metalworkers how to cast bronze, silver, and gold to produce musical, navigational, and surgical instru-ments, as well as dishes for the tables of rich Florentine merchants.

Art was a serious business in Florence, and Verrocchio's students spent many hours watching the master draw up contracts to fill commissions and collect payments for finished artworks.

Verrocchio's workshop was governed by a strict hierarchy. The master ran the business and assigned the work. His most trusted assistants were established in the artists' guild, having sold major works to earn their membership. The next rank below the masters were the journeymen, who were proven artists but had never sold a major work. The journeymen oversaw the apprentices, young boys and men, most of whom were bound by legal

LEONARDO'S HORRIBLE MONSTER

Leonardo's first biographer, Giorgio Vasari, wrote about a horrible monster the young Leonardo, possibly twelve years old at the time, painted by using the strangest animals he could find as models. Vasari describes in Lives of Painters, Sculptors and Architects *how Leonardo constructed the head of Medusa, a hideous monster from Greek legend.*

"Lionardo took lizards, newts, maggots, snakes, butterflies, locusts, bats, and other animals of the kind, out of which he composed a horrible and ter-rible monster of poisonous breath . . . belching poison from its open throat, fire from its eyes, and smoke from its nostrils, of truly terrible and horrible aspect. He was so engrossed with the work that he did not notice the terrible stench of the dead ani-mals, being absorbed in his love for art. . . . [When] it was finished . . . Piero took Leonardo's work se-cretly to Florence and sold it to some merchants for 100 ducats [a large sum], and in a short time it came into the hands of the Duke of Milan, who bought it . . . for 300 ducats."

contract for a certain number of years. In some cases, apprentices paid Verrocchio for their lessons. In return for their services, Verrocchio promised to teach them the craft, provide room and board, clothe them, and, on occasion, give them pocket money. It was understood that although works would be signed by Verrocchio, and he was given credit for them, they were often completed with major help from the master, as well as the journeymen and apprentices.

Because of his father's influence, Leonardo was never formally a lowly apprentice to Verrocchio. He did, however, live in the famous artist's house, performed the work appointed him, and eventually became chief assistant.

THE GIFTED YOUNG MAN

Leonardo, the artist, musician, and intellectual, had obviously rejected his father's mercenary approach to life. He despised greed, had little regard for money, showed no interest in legal affairs, and did not know Latin until he was middle aged.

Like his father, however, he would often work for many different powerful people who were at odds with one another. And Leonardo did inherit his father's strong will and hardy physical makeup. Another trait, perhaps inherited from his mother, was his unusual beauty. In the mid–sixteenth century, Leonardo's first biographer, Giorgio Vasari, described a young man,

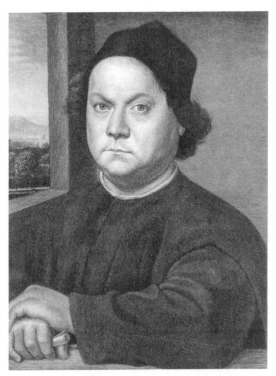

Ser Piero brought the teenage Leonardo to Andrea del Verrocchio (pictured), an established Florentine artist. Under Verrocchio's tutelage, Leonardo developed his painting, sculpting, and metalworking skills.

whose personal beauty could not be exaggerated, whose every movement was grace itself and whose abilities were so extraordinary that he could readily solve every difficulty. He possessed great personal strength, combined with dexterity, and a spirit and courage invariably royal and magnanimous.[13]

When Leonardo was not working for Verrocchio, he was often seen on the streets of Florence. It is said that people often stopped to look at the beautiful young man. Like his namesake the lion,

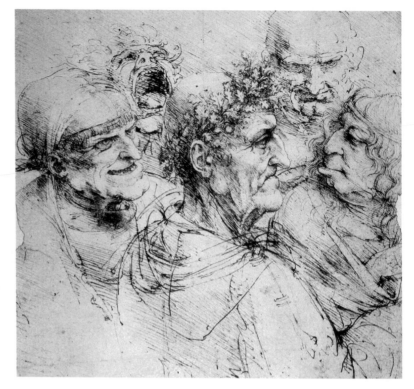

A sketch of Leonardo's shows five faces of varied expression. Leonardo enjoyed observing faces that caught his attention, studying their features, and capturing the detail on paper.

Leonardo sported a mane of long curly hair and a flowing beard, which he took special care to keep clean and well groomed. He often wore a short rose-colored coat that reached only to his knees, even when long garments were in fashion. Leonardo favored rose-colored clothing, a fashion that was reserved for nobility, suggesting that he regarded himself as belonging to noble background.

Yet in spite of his many gifts, Leonardo was not egotistical. A modern biographer, Ludwig H. Heydenreich, discusses this paradox:

> For all his proud consciousness of self which can be sensed in his writings, Leonardo was a stranger to any feelings of arrogance. . . . We are left with

the impression that Leonardo was, throughout his life, his own most objective observer. This great experimenter whose life was, in essence, one uninterrupted chain of experiments, must have regarded himself as his own most valuable experimental instrument. Only by this impersonalization of his own *ego* can we explain the otherwise incomprehensibly cool observation with which Leonardo looked at all living phenomena.[14]

And while Leonardo was often fondly observed by people in the street, the young man spent many hours observing those who passed by him. The portraits of strangers often turned up as sketches in the artist's notebook. Vasari elaborates:

Lionardo was so delighted when he saw curious heads, whether bearded or hairy, that he would follow about anyone who had thus attracted his attention for a whole day, acquiring such a clear idea of him that when he went home he would draw the head as well as if the man had been present. In this way many heads of men and women came to be drawn.[15]

Young, talented, and handsome, Leonardo seemed to have it all. He lived and worked in the studio of Verrocchio, near his father's elegant house in Florence. He would often go out to the countryside to draw, or to visit his grandfather's estate in Vinci, or his mother's house above Vinci. He rode horses, sang and played the *lira de braccio,* a stringed instrument somewhat like a viola.

LEONARDO'S FIRST SELF-PORTRAITS

Like most artists, Leonardo practiced his art by drawing his own face. In Leonardo, *Robert Payne describes the first known self-portrait of the young Leonardo.*

"There exists among the Leonardo drawings . . . a single sheet on which Leonardo has drawn no less than thirty separate portraits and figures, using both sides of the paper. Some are drawn sketchily, others with great care, and they fall upon the page in a manner that suggests they were all made in a single prolonged sitting. We see the father with the beaked nose and the jutting chin, and near him a profile of a handsome, delicately featured youth with an abundance of curly hair. Below the youth is a young woman who closely resembles him and who may be his mother, Caterina. On the other side of the sheet the youth is drawn six times. Three of these drawings are clustered at the foot of the page and are balanced by three lion heads. One of these lions, in the process of becoming a dragon, is actually issuing from the youth's head. . . .

For Leonardo the lion, *leone,* served as a [symbol] for his own name. When he drew the three lions and the three profiles at the foot of the page, he was writing his own signature.

The portraits therefore are self-portraits, and the young Leonardo, who appears here for the first time, was clearly interested in his own features to the extent that he could draw himself seven times on a single sheet of paper."

Leonardo spent his nights socializing with the gifted young Florentines. If he needed money, he could get some from his father or earn some by playing the *lira* for those who could afford his services. He was a virtuoso performer famous for his sweet singing voice and improvisations on the *lira*. Indeed, Leonardo had so many talents the difficulty lay in choosing which one he would pursue.

Chapter

2 The Artist in Florence

The city of Florence in the late fifteenth century was the perfect environment for a young artistic talent such as Leonardo da Vinci. As a cultural center, Florence had its own styles of art and architecture that were internationally famous. The city's fine marble buildings and large libraries were the centers of European arts and letters.

As a hub of commerce, the city was a financial mecca for banks that financed kings and governments all over Europe. And, according to art historian Ivor Hart, "Florentine bankers and merchants were to be found all over the world—often in the advisory service of foreign governments."[16]

Florence, with a population well over one hundred thousand was built on the banks of the Arno River, which was spanned by five magnificent bridges. The city was home to about 150 churches, monasteries, and other religious houses, and its main streets contained over one hundred shops. Florence was famous for its silk and wool cloth, which was sold all over Europe and as far away as the Near East. The city's wool guild had almost

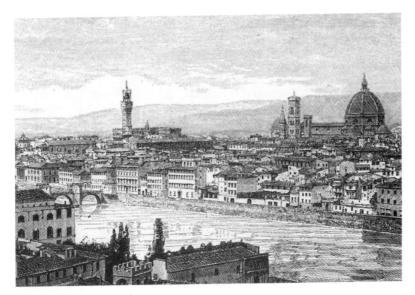

The shops and homes of Renaissance Florence hug the banks of the Arno River while the Florence cathedral is visible at the far right.

three hundred shops and the silk weavers over eighty.

The narrow winding streets of the city were crowded with visitors from Italy, the rest of Europe, and Asia. On holidays, buildings were draped with decorative banners while parades featured colorfully costumed musicians, singers, and dancers. On the city's major squares armor-clad young men on horseback held jousting contests with long lances. Religious holidays were marked by somber priests and monks who led processions through the streets carrying banners emblazoned with holy icons.

In 1928, author and poet Rachel Annand Taylor described the beauty of fifteenth-century Florence:

> In Leonardo's day [Florence] lay beautiful by her green-yellow river, still gripped by her strong walls and locked by her ancient gates, though the cool villas climbed the slopes of her serene and reasonable hills. . . . From the heights she seemed an arrangement in plaques of ivory, softly stained red and green and topaz, richly blurred at the edges. White spaces showed her many piazzas, green spaces her many gardens. Her beautiful bridges went with graceful steps across her river.[17]

THE LANDSCAPE DRAWING

The beauty of Florence and the stunning landscapes of Vinci played an important role in Leonardo's development as an artist. On August 5, 1473, Leonardo made his first signed drawing, called *Feast of Santa Maria delle Neve*. The picture features an expanse of natural scenery and is considered the first true landscape in art. In this work, Leonardo seems to have actually drawn a picture of the atmosphere through which the human eye perceives objects at a distance. Ludwig Heydenreich elaborates:

> Light and humidity modify our perception; Leonardo understands and has investigated the causes of sharply or hazily defined shapes, of clear or misty distances. This recognition of a phenomenon itself reveals his creative mind, quite apart from the artistic genius which enabled him to reproduce, to give visible form to the knowledge that resulted from his observations. For Leonardo had first of all to invent new graphic means, capable of expressing in drawings what his eye had perceived.[18]

Several years later, Leonardo's landscape technique appears once again, this time in a work done in Verrocchio's studio. In 1476, Verrocchio and his assistants finished what is considered one of his finest paintings, a depiction of the baptism of Jesus by St. John. In the work, called the *Baptism of Christ*, the figures of Jesus and John the Baptist are rendered in the thin, bony form seen in many of Verrocchio's other works.

The contributions to the painting made by the twenty-four-year-old Leonardo, however, are impossible to overlook. The sensitively drawn head of an angel kneeling

nearby seems to glow. The landscape beyond shows Leonardo's magical touch, with dramatic cliffs and mountainsides seen through a light atmospheric haze. The fine details in the water, trees, and fields pull the eye away from Verrocchio's stiff figures to the sections painted by the young artist.

Heydenreich explores the importance of Leonardo's early landscapes in relation to other painting styles at the time:

> This fragment of nature opens up a new realm of vision, for what is shown here had never been depicted before. Italian, and especially Florentine painting had not as yet developed much feeling for landscape. Its great theme had been the human figure, so that landscape had been conceived only as a form of environment, as a foil to man's activities. Nature had been appreciated only as a kind of arcadian element for the human beings inhabiting it. Thus Leonardo was the first and, for a long time, the only Italian painter to see Nature in [contrast] to Man; to contemplate and evaluate landscape for its own sake—landscape, in fact, as Nature.[19]

Leonardo's work on the *Baptism of Christ* was done with oil paints, which resulted in a gleaming surface, much more delicate than the flat tempera surface of the rest of the painting.

Painting in oil was a relatively new art. The technique, introduced to the Florentines by the northern masters, was not yet in common use in Florence, and Leonardo was experimenting with the new medium. For years Verrocchio had worked very hard

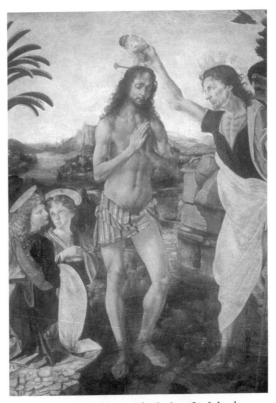

The Baptism of Christ, *depicting St. John baptizing Jesus, was created in Verrocchio's studio by Verrocchio, Leonardo, and other assistants.*

at painting, spending many weary nights toiling to reach his ideal. In this painting Leonardo had already come closer to that ideal than Verrocchio had in all those years. Verrocchio may have been relieved to have such a painter in his studio, since he preferred sculpting to painting.

MORE EARLY MASTERPIECES

When Leonardo was not helping to complete works by Verrocchio, he began to work on his own paintings. Around 1478, Leonardo completed the *Annunciation*,

a work only six inches high and twenty-three inches long. The painting depicts the archangel Gabriel telling the young Mary that she is to fulfill the biblical prophesy and bear a son named Jesus.

Mary is depicted without a trace of emotion to disturb her delicate features. The faces show an unearthly softness and lightness, mysterious expressions without any shadows. Leonardo writes in his notebooks about the beauty of such forms, which were nearly impossible to paint. He compared the look to seeing faces in the morning before the sunlight has appeared, or in the early evening when the sun has just gone down. But as esteemed art historian Frederick Hartt wrote, Leonardo had methods for re-creating such difficult images:

To produce such effect in the studio, he recommends painting all four walls of a courtyard black, stretching a sheet of linen over the courtyard, then placing the model under this linen, so that a diffused light will irradiate the face, with no sharp reflections or shadows to break up the forms. This is exactly the effect that Leonardo has achieved in his mysterious and enchanting *Annunciation*.[20]

Emerging from darkness, overlaid with bluish atmosphere, Leonardo's colors enjoyed a new and deeper resonance and a more convincing three-dimensional appearance than the bright, hard forms of his contemporaries. No other Florentine painter of that time could paint such an atmospheric veil of blue air as seen in the landscape behind

The Annunciation *is lauded for its delicate, misty atmosphere, which softens the forms and eliminates shadows, and its realistic features such as the angel's wings.*

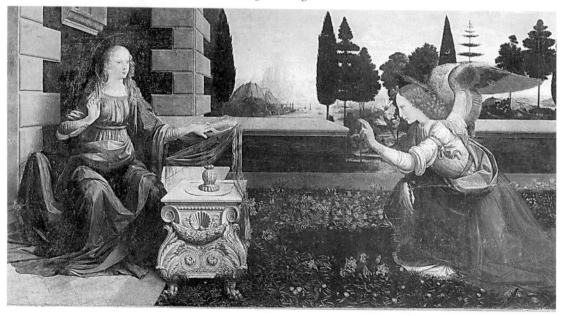

Mary and Gabriel in the *Annunciation.* Ariane Ruskin wrote:

> The background of this picture, the cypress and pine of Tuscany silhouetted against the misty never-never land of [Leonardo's] own imagination, has impressed viewers ever since it was painted. It is [also] interesting that the angel's wing was the first in art to be a true depiction of a bird's wing.[21]

In addition to *Annunciation* there remain only six other paintings, two of them unfinished, that can be attributed to Leonardo's Florentine period. As Robert Payne writes:

> Some of [the other] paintings [of this period] have been lost, some destroyed during the interminable wars of Italy . . . while others were sent abroad and may be mouldering in ancient monasteries or noblemen's houses, and still others perished by neglect. He was incapable of painting anything less than a masterpiece, and the loss is therefore appalling.[22]

The four finished paintings are considered authentic masterpieces. In the Benois *Madonna,* the *Adoration of the Magi, St. Jerome,* and *Ginevra de' Benci,* Leonardo proved that he could paint with freedom and skill thought virtually impossible at that time.

Leonardo received his first independent commission on January 1, 1478. He was to paint a picture for the altar of the Chapel of St. Bernard in the city hall of Florence, the Palazzo della Signoria (known from the sixteenth century on as the Palazzo Vecchio). He received his first payment on March 14 and began to experiment with the colors and make preparatory sketches. As with many later projects, Leonardo abandoned the altarpiece once the work was underway. Following the practice of the time, several other painters completed the project.

THE *ADORATION OF THE MAGI*

Just before his thirtieth birthday, Leonardo's father helped him secure a contract with a monastery for a painting called *Epiphany,* also known as the *Adoration of the Magi.* Epiphany, a prime Christian feast, is celebrated on January 6, the twelfth day after Christmas.

The painting is about eight-by-eight feet and was to be the central painting for the altar at the monastery. Instead of using a single perspective, Leonardo combined several viewpoints to show the great variety of people, animals, buildings, and landscapes in the work. The painting was considered more radical and expressive than anything painted before. His *Epiphany* has been called "the least quaint and most intellectual design produced in the Christian world up to that date."[23] Because the painting was so radically different in style and content, it was never used by the monastery. Leonardo may have added parts of the painting's background years later, giving it a complexity that almost demanded it be left in the state of a painted sketch.

Lost and Found Masterpieces

In the nearly five hundred years since Leonardo died, an untold number of his works have been destroyed or otherwise lost to history. St. Jerome in the Desert is an example of a priceless masterpiece that was nearly lost. Robert Payne tells the story of St. Jerome *in* Leonardo.

"It appears that [the work] had once belonged to the painter Angelica Kauffmann. . . . She died in November 1807 and her collection of paintings was dispersed, many of them going to Spain. The St. Jerome vanished, to reappear thirteen years later in a sale room in Rome without the head, which had been cut away. The part of the panel with the head had been used as the door of a small wardrobe. The purchaser was Cardinal Joseph Fesch, the uncle of Napoleon, an avid art collector who instituted a search for the part that had been sawed off. Five years later the head was found in a cobbler's shop, where it was being used as a wedge to support the bench. The head was inserted in the panel, the restorers went to work, and the complete painting was recognized as an early work by Leonardo. There was not a single document to authenticate the painting, but this scarcely mattered. It belonged to the category of paintings that do not demand authentication because they are so obviously painted by the master that no one dares to suggest otherwise."

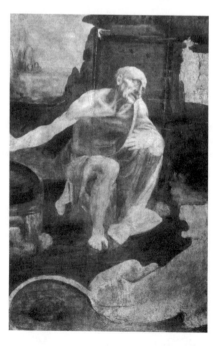

Leonardo's St. Jerome in the Desert *was lost for years, cut apart, and finally repaired and restored.*

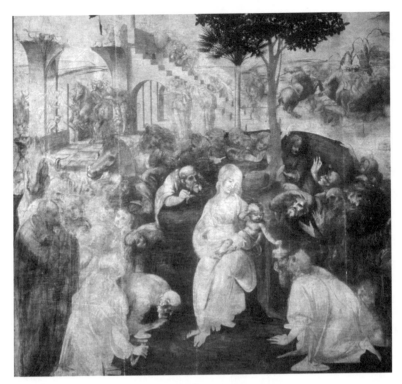

The Adoration of the Magi, *created for the altar of a monastery, was considered too radical and the monks did not accept the painting.*

Magic Tricks, Storytelling, and Singing

When Leonardo was not drawing, painting, mixing pigments, or helping Verrocchio, he spent his time attending parties, drinking, and amusing himself with brash stories and magic tricks. Bramly writes:

> [The young artists] loved parties, liked to distinguish themselves from respectable citizens and indeed shock them. Leonardo, too, was not above amusing himself at others' expense. He invented (or claimed as his own) riddles, charades, puns, and funny stories. . . . Leonardo was rather addicted to conjuring tricks—springing perhaps from his scientific turn of mind. He would make multicolored flames jump from a cup of boiling oil by throwing red wine into it; he would break a stick balanced on two glasses without cracking them; he would moisten a pen with saliva and then write black letters on paper with it. He manufactured all sorts of stinkballs from the remains of fish or animals allowed to decompose in a vessel—and so on.[24]

Leonardo's taste for tricks and jokes brought him into contact with a wide array of people outside of mainstream society, such as magicians and experts in occult sciences such as fortune telling.

Leonardo might have loved a funny story for its own sake, but—ever the artist—he also used his humorous tales to develop character sketches for his paintings.

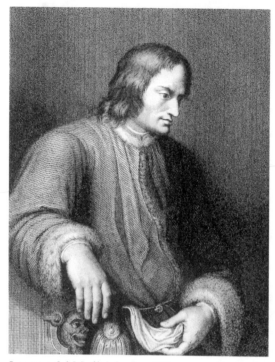

Lorenzo de' Medici, leader of Florence and patron of the arts.

In 1585, artist G. P. Lomazzo advised his students to follow Leonardo's way of studying expression and movements.

> There is a tale told . . . that Leonardo once wished to make a picture of some laughing peasant. . . . He picked out certain men whom he thought appropriate for his purpose and after getting acquainted with them, arranged a feast for them with some of his friends, and sitting close to them he proceeded to tell the maddest and most ridiculous tales imaginable, making them, who were unaware of his intentions, laugh uproariously. Whereupon he observed all their gestures very attentively and those ridiculous

things they were doing, and impressed them on his mind, and, after they had left, he retired to his room and there made a perfect drawing which moved those who looked at it to laughter as if they had been moved by Leonardo's stories at the feast.[25]

In addition to storytelling, artists in Verrocchio's workshop sang songs and played various musical instruments. Leonardo's fine voice could often be heard above his custom-made lyre, and impromptu concerts might become rowdy affairs, Bramly reports, "especially if wine was available."[26]

THE CALM OF FLORENCE IS SHATTERED

During the years that Leonardo worked in Florence, mostly in Verrocchio's studio, the city enjoyed peace and prosperity. On Easter Sunday, April 26, 1478, the peace of Florence was shattered by a series of violent events that changed Florentine history and the life of Leonardo da Vinci as well.

Although technically governed by an elected assembly, Florence was actually ruled by a banking family named Medici, which was headed by two well-respected brothers named Lorenzo and Giuliano. Both men lived quietly and were patrons of the arts and letters while lending financial support to institutions such as hospitals, monasteries, and schools.

The success of the Medicis inspired hatred and jealousy among other wealthy families, however, and the Pazzi clan hatched a plot to kill Lorenzo and Giu-

liano and seize power in the city. The Pazzi conspiracy was aided by the king of Naples and Pope Sixtus IV, who wanted to transfer the power over Florence to a member of his own family. These high-ranking plotters were joined by a group of non-Florentine malcontents, hired outlaws, and other conspirators. (At that time, before Italy had become a unified country, its independent city-states, such as Florence, Naples, and Venice, were often in conflict with one another.)

On Easter morning, 1478, several high-ranking conspirators went to the Medici palace to accompany the two brothers to church for high mass. At the climax of the service, the conspirators fell upon the Medicis with knives, stabbing Giuliano

LEONARDO'S WRITINGS

The left-handed Leonardo recorded his thoughts in a curious manner in his notebooks: in script that ran backward from right to left. This manner of writing prevented most people from being able to read Leonardo's thoughts, though the words may be legible if one holds the page up to a mirror. Biographer Serge Bramly discusses Leonardo's writings in the book Leonardo: Discovering the Life of Leonardo da Vinci.

"'Do not tell lies about the past,' Leonardo writes, but in fact he rarely mentions the past. His notebooks constitute neither a private journal nor memoirs. When, at about thirty, he began to keep a systematic record of his thoughts—writing down observations and reflections in the little notebooks he carried everywhere—he did not imagine he was leaving a record of himself. The thousands of pages covered with his reverse, left-handed script, some of it illegible, amount, some have said, to the raw material for a huge encyclopedia. All too rarely does one discover—scribbled between plans, observations, descriptions, or calculations—some item of personal detail: a moral reflection, a note of expenditure, the draft of a letter, someone's name, a maxim, a list of books to be borrowed or of things not to forget. And even these echoes of life seem to be there by accident. For example, at the bottom of one page devoted to descriptive geometry and the canalization of rivers are the words: 'Tuesday: bread, meat, wine, fruit . . . salad.' There are very few confidences in these pages. Leonardo reveals his innermost feelings indirectly. . . . But then writing down one's emotional experiences was not common practice in Renaissance Italy. To find Leonardo the man, one has to read between the lines."

nineteen times. Lorenzo, though stabbed in the throat, managed to escape.

As Lorenzo's friends spirited him away, Archbishop Francesco Salviati—the pope's nephew—attempted to seize the Palazzo della Signoria, the seat of the government. But, according to Bramly:

> Far from rebelling against their ruler, the townspeople unanimously took his side, acclaimed him, and pursued the conspirators, who included a number of priests. They were hunted down to their houses, and before long corpses were dangling outside the law courts and paraded on the ends of pikes,

hideously mutilated. The crackdown continued in the following weeks, with the judges passing a hundred or so death sentences. The Pazzi name was banned by decree. . . . Finally, as was sometimes done in cases of high treason against the state, a painter [Botticelli] was commissioned to depict . . . the execution of the guilty men.[27]

When it was over, the political air in Florence was rife with suspicion. Lorenzo discovered that members of several prominent families were involved in the Pazzi conspiracy. The king of Naples had shown himself to be an enemy, and before the year was out, the city of Florence was openly at war with Pope Sixtus IV.

THE MILITARY ENGINEER

During the war Florence waged against Rome and Naples, Leonardo had many opportunities to become familiar with the arms and machines used to attack and defend the city. Seeing these machines stimulated his imagination and gave him ideas. Leonardo turned his intellectual powers to military engineering and design during the war. The artist seemed to be fascinated by military vehicles, and he

RENAISSANCE ITALY

began to fill notebooks with sketches of innovative and unusual weapons of war. One drawing shows early designs for an armored tank, another depicts a horse-drawn, wheeled cart with vicious, razor-sharp scythe blades rotating on the sides, which were meant to cut down enemies by slicing them in two. As Leonardo wrote in his notebook, the scythes would "mow down men like a field of grain."[28]

Leonardo also designed various rope ladders and grappling hooks to defend the city walls. These are described by Charles Gibbs-Smith and Gareth Rees in *The Inventions of Leonardo da Vinci*:

> Around 1479, when the Florentine garrisons were under siege, Leonardo naturally became preoccupied with methods of attacking and defending walls. [I]t was a question of going over the methods of medieval military engineers and adding the characteristic touch of ingenuity that is found in so much of Leonardo's work. [His] drawings show how [he] approached the taking of a wall by assault if a breach could not be made by gunfire. Had mountaineering been a leisure pursuit of Leonardo's day, some of this equipment would have been useful!

> The drawings show firstly an assortment of rope ladders and rigid scaling ladders. Some have a grappling iron to hook them over the top of the wall, others a spike to drive into the ground at their base. Secondly, a man is shown scaling the wall of a fortress across a moat with the assistance of a rope ladder very similar to the ratlines used for climbing the masts of sailing ships. Thirdly a man is shown scaling a wall with the help of pitons of various sizes and shapes. As he climbs he makes holes for pitons above him with the help of a sharpened brace, at the same time pulling up a rope ladder for a subsequent assault force.[29]

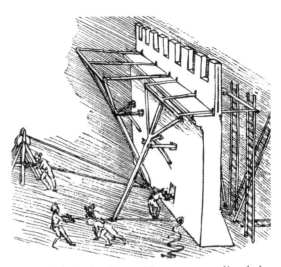

Leonardo's device for pushing enemy scaling ladders away from a wall. War with Rome and Naples prompted Leonardo to invent methods of defending Florence's city walls.

THE CALL TO MILAN

While Leonardo was inventing various devices to defend Florence, the city's leader, Lorenzo de' Medici, was anxiously searching for outside allies to help him defend his power. In desperation, Lorenzo contacted a man who was an ally, but with whom he had little in common: Ludovico

LEONARDO, THE MILITARY ENGINEER

When war came to Florence, Leonardo spent much of his time thinking up new ways to fight battles. In a letter to Ludovico, the ruler of Milan, Leonardo listed his many skills as a military engineer. The letter is reproduced in Ivor B. Hart's The Mechanical Investigations of Leonardo da Vinci.

"1. I have a process for the construction of very light bridges, capable of easy transport, by means of which the enemy may be pursued and put to flight; and of others more solid, which will resist both fire and sword, and which are easily lowered or raised. I know also of a means to burn and destroy hostile bridges. . . .

3. Item; if, by reason of its elevation or strength, it is not possible to bombard a hostile position, I have a means of destruction by mining provided the foundations of the fortress are not of rock.

4. I know also how to make light cannon easy of transport capable of ejecting inflammable matter, the smoke from which would cause terror, destruction, and confusion among the enemy.

5. Item; by means of narrow and tortuous subterranean tunnels, dug without noise, I am able to create a passage to inaccessible places, even under rivers.

6. Item; I know how to construct secure and covered wagons for the transport of guns into the enemy's lines, and not to be impeded by ever so dense a mass, and behind which the infantry can follow without danger [a possible version of a modern tank.]. . . .

8. Or if the use of cannon happens to be impracticable, I can replace them by catapults and other admirable projecting weapons at present unknown."

Sforza, the duke of Milan. Lorenzo, who was a poet, was called "Lorenzo the Magnificent" for his kindness and generosity. He created a brilliant court culture of poets, philosophers, and painters that included Leonardo. Ludovico, on the other hand, was known for his overriding desire for power.

Sforza means "force," and the name says much about the man. Robert Payne writes:

Unlike Lorenzo de' Medici, Ludovico had no pretensions to intellectual authority. He was incapable of discussing abstractions, or of writing poetry, or of evaluating a work of art. He was the sum of his appetites, and

his largest appetite was directed toward retaining and expanding his power.[30]

In spite of this, Ludovico's court was the center of famous theatrical events, musical galas, parties, and feasts. Lorenzo decided to send the great Leonardo da Vinci to Milan to gain favor with Ludovico.

Leonardo, eager to escape the warlike atmosphere of Florence, accepted the task and wrote a letter to Ludovico that outlined the ways he could be of service. But instead of mentioning the skills as an artist and musician on which his reputation was based, he appealed to Ludovico's quest for power. Leonardo divided the letter into ten numbered paragraphs that describe his expertise as a military engineer, outlining details of powerful machines of war for use on both land and sea, and explaining that he could contrive superior guns, mortars, bombs, and catapults.

Finally, at the end of the letter, Leonardo lists his other abilities:

In time of peace I believe I can give perfect satisfaction and to the equal of any other in architecture and the composition of buildings public and private; and in guiding water from one place to another.

Item. I can carry out sculpture in marble, bronze or clay, and also I can do in painting whatever may be done, as well as any other. . . . And if any of the above-named things seem to any one to be impossible or not feasible, I am most ready to make the experiment in your park, or in whatever place may please your Excellency—to whom I commend myself with the utmost humility, etc.[31]

Before long, Leonardo was on his way to Milan—and on to an entirely new phase of his life.

Chapter

3 Art and Science in Milan

When Leonardo was about thirty years old he arrived in Milan with his friend Atalante Migliorotti, a famous Florentine musician. Leonardo was carrying a beautiful silver lyre, a gift to Ludovico. The precious and unique lyre was described by Vasari as "made by [Leonardo] in silver, and shaped like a horse's head, a curious and novel idea to render the harmonies more loud and sonorous."[32]

What Leonardo found in Milan was a large fortified city about three times the size of Florence. The city was built out of tawny brick and gray stone and surrounded by high walls that had seven gates guarded by fifteen heavily fortified towers. A wide moat surrounded the castle and each entrance was protected by a massive drawbridge. Within this fortress lay the forbidding Castello Sforzesco, the castle of Ludovico Sforza, duke of Milan. "One of its particular features," says Bramly, "was that it was more fortified on the side facing the city, as if the ruling family feared an uprising by its subjects more than external aggression."[33]

Like Florence, Milan was a city of wealth and luxury. Its three hundred thousand people worked in many varied industries. Around fifteen thousand peo-

ple worked in the silk spinning and weaving trade, and as many in the wool industry. The streets of the city sprawled out into the nearby plains that were watered from the crystal-clear mountain streams that flowed down from the distant Alps. Mulberry trees dotted the countryside, and, a relatively new crop to the area, rice enriched the agricultural sector. Bramly describes the city:

[Milan,] often wreathed in mist, must have seemed another world to Leonardo, to belong to northern Europe—or perhaps to another century. No town planners had supervised building here: huddled together higgledy-piggledy, medieval houses made up a labyrinth of streets, noisy, narrow, dirty, and full of variety, interrupted here and there by canals where frogs chorused nightly. Leonardo might have glimpsed an occasional "modern" building. . . . But the great majority of palaces and churches, whether or not they dated from previous centuries, were in the Romanesque or Gothic style, especially that exaggerated Gothic sometimes described as "flamboyant."[34]

The walls of the city's buildings were decorated with murals depicting wreaths, flowers, and symbolic animals, which lent a gaiety to the streets and softened the city's fortifications and embattlements.

MILITARY MILAN

Milan's position in the middle of all trade and military invasion routes in Italy guaranteed the city a long history of conflict and warfare. In turn, the major industry that gave Milan its fame and prosperity as far back as the thirteenth century was the manufacture of arms. As Ivor Hart writes:

> More than a hundred workshops were busy with the forging and hammering and shaping and filing of both armour and handweapons; and in the [Street of the Armorers] were concentrated shop after shop, with their crowded display of armour both for knights

and their steeds, and of lances, pikes and halberds. It was an impressive sight and helped to reflect the inevitably military atmosphere which had become so natural to the city.[35]

By the time Leonardo arrived, around 1482, the Milanese were the leading arms manufacturers in Italy. The rulers of Venice were building up armies of mercenary soldiers and were threatening Milan, which might soon be obliged to make use of its military products to defend itself.

Leonardo assumed, correctly, that the duke of Milan needed military engineers more than artists. Leonardo was also motivated to promote himself in that role by self-interest—the social status of a military engineer was higher than that of a painter.

> For a [man] seeking glory, frescoes and painted panels were but fragile decorations; bronze and marble had a better chance of surviving down

A woodcut of Milan from 1493, when Leonardo lived there, shows the walls, towers, and gates of this heavily fortified city.

through the centuries; a great building made it even more likely one would remain in people's memories; but all that was nothing unless one possessed the political and military might that enabled such things to be created and maintained.[36]

Leonardo's hopes were dashed, however, when Ludovico chose another man to be his chief military engineer.

In Ludovico's Court

Leonardo had come to Milan full of hope and anticipation, and Vasari gives the impression that Leonardo made a brilliant debut at Ludovico's court, followed by immediate success:

> The duke, captivated by Lionardo's conversation and genius, conceived an extraordinary affection for him. He begged him to paint an altar-picture of the Nativity, which was sent by the duke to the emperor.[37]

No trace of the altarpiece exists, and recent historians have concluded that Leonardo did not win court favor so quickly. His new patron, Ludovico, however, did give him a salary at times, and Leonardo was appointed the task of creating an equestrian statue—called the *Great Horse* by Leonardo—in the memory of Francesco Sforza, Ludovico's father. The duke, however, was slow to fund the *Great Horse*, unsure that Leonardo could complete such a large project. In the meantime, Leonardo was free to accept individual commissions in addition to his court duties, but they were few and far between.

Because of his humble financial situation, Leonardo shared both a studio and lodgings with a family named Predis, made up of six brothers who were also artists. The Predis brothers had varied talents, from woodcarving to painting, and they were well connected at court.

So, as Hart concludes:

> Leonardo was free to alternate between his many sketches and studies in preparation for "the horse," his duties as master of ceremonies for the many fêtes and carnivals at court, his occasional "outside" commissions as a painter, and his beloved notebook studies and indoor experiments in the various fields of science and engineering that were his continual interest.[38]

Music and Pageantry

Some historians believe that Leonardo was sent to Milan as much for his musical talents as for his other abilities. Music played a very important part in court festivities, which Leonardo helped to organize, create, and perform for the rulers of his day. The splendor and glamour of these festivals, enjoyed often in the Renaissance courts, can hardly be imagined today. They included feasts, musical plays, masquerades, parades, jousts, tournaments, and various entertainments lasting far into the night. Famed historian

LEONARDO'S GREAT HORSE

When Leonardo moved to Milan around 1482, he was promised a commission to make an enormous bronze statue of a horse carrying an armor-clad rider to grace the tomb of Duke Francesco Sforza, the father of Ludovico. Leonardo planned the statue for years, studying the anatomy of horses and sketching designs of wild poses never used in a monumental sculpture before. He designed a statue that would use ten times more metal than had ever been used on a single work, and he planned to cast it in one piece by pouring metal into four furnaces at once.

Eventually, in 1493, Leonardo completed a full-scale clay model of the *Great Horse,* which was twenty-six feet high. The giant model excited wonder and fascination when it was unveiled in the courtyard of Castle Sforza during the wedding festival of the duke's niece.

Meanwhile, Leonardo filled dozens of pages with sketches and formulas in an attempt to solve the many problems involved with casting such a huge sculpture. The artist tested ingredients to be used in the mold, such as crushed brick, ashes, and river sand. By 1494, he had designed a casting pit down to the finest details.

Just as Leonardo was about to execute this massive undertaking, the French invaded northern Italy, and the precious bronze the artist had planned to use for the statue was shipped on barges to Ferrara to be cast as a cannon. Although the *Great Horse* was never made, two hundred years later, a French sculptor, following Leonardo's plans, cast a giant bronze statue more than twenty-two feet high to honor Louis XIV.

Leonardo sketched many different poses for his Great Horse *statue.*

Will Durant described life in the Sforza castle in *The Renaissance:*

> The court of Milan [was] the most splendid not only in Italy but in all Europe. The Castello Sforzesco [Castle of Sforza] expanded to its fullest glory, with its majestic central tower, its endless maze of luxurious rooms, its inlaid floors, its stained-glass windows, its embroidered cushions and Persian carpets, its tapestries telling again the legends of Troy and Rome; here a ceiling by Leonardo, there a statue by Cristoforo Solari . . . and almost everywhere some luscious relic of Greek or Roman or Italian art. In that resplendent setting scholars mingled with warriors, poets with philosophers, artists with generals, and all with women whose natural charms were enhanced by every refinement of cosmetics, jewelry, and dress. The men, even the soldiers, were carefully coiffured and richly garbed.[39]

Leonardo's various talents were useful in such an atmosphere. The historian Paolo Giovio, born in 1543 and one of the first to write about Leonardo, said:

> [S]ince he was a connoisseur and marvelous inventor of all beautiful

A corner tower at the Castello Sforzesco in Milan. Ludovico filled his castle with lavish decorations and entertained his court with nightly festivities.

MUSIC AND MILITARY DESIGN

The drawings of weapons and military machines that Leonardo made proved that he was a brilliant thinker in times of war. But as Serge Bramly writes, in Leonardo: Discovering the Life of Leonardo da Vinci, *Leonardo used the same type of reasoning to design weapons as he did when inventing musical instruments.*

"Curiously, all these inventions and improvements [in weaponry] are in the same mold as his excursions into the world of musical instruments: his method was always to organize, assemble, and mechanize any given activity, limiting the role of human intervention and trying to achieve with a single machine what was normally the work of several. For example, he invented a drum struck by five sticks attached by cogwheels to carriage wheels, so that as the carriage moved, the drum automatically played complicated rhythms. In much the same way, he designed a gun battery arranged like a set of organ pipes mounted on wheels: eleven barrels would fire, then as the carriage advanced, another set of barrels would move automatically into position, and so on. He also designed a system to push away scaling ladders from a wall, three or four at a time; and he thought of linking several gun barrels to a single carriage—prefiguring the machine gun—just as he envisaged a bell to be struck by four hammers activated by a keyboard, so that, as he said, one bell would 'produce the effect of four bells.' To a mind like his, so preoccupied with efficiency, there was perhaps not much difference between an innocent carillon and an artillery battery vomiting a continuous stream of flame and metal."

things, especially in the field of stage performances, and sang masterfully to his own accompaniment on the lira, he was beloved by all princes through his whole life.[40]

Leonardo did much more than play music and sing. The art of making musical instruments was in the early stages of experiment during this time, and Leonardo built instruments of differing pitch to achieve chord effects that expanded the general knowledge of harmony in music. Leonardo was also fascinated by the human voice, which he called "that most sensitive of musical instruments,"[41] and he studied the anatomy of the human organs that produce the voice. He compared the windpipe to the pipe organ.

Leonardo opened new musical horizons with his musical inventions, many

based on his studies of anatomy. He designed mechanical instruments, stringed instruments, toys and folk instruments, drums, tunable bells, wind instruments, and a complex instrument called the *viola organista,* a string instrument with a keyboard, in which the strings are made to vibrate by a mechanical device.

VIRGIN OF THE ROCKS

One of the artists that Leonardo lived with, Ambrogio da Predis, was well known for his portraits. In addition Predis had recently been made official painter to the court of Milan. Together Leonardo and Predis were given a commission by the monks of the Confraternity of the Immaculate Conception of the Blessed Virgin Mary to paint an altarpiece for the Chapel of San Francesco Grande. Today the painting is known as *Virgin of the Rocks*—a name it was given later, for Leonardo never gave titles to his works.

The artists were given a contract, drawn up by the monks and their lawyers and signed April 25, 1483, in which every detail of the painting was spelled out. The contract, which covered several pages, half in Latin, half in Italian, specified that Leonardo would paint the middle panel of the altarpiece in oils, and then went on to describe the figures and colors to be painted:

> Item: Our Lady in the center must have her outside dress clothed in brocade of gold and ultramarine [blue].

> Item: The gold brocaded gown must be done in fine red lacquer and oil paint.

> Item: The lining of the vest, brocaded with gold and green done in oil. . . .

> Item: God the Father—the vestments above brocaded in gold with azure ultramarine.

> Item: The angels must be adorned in gold above their gowns, done in the Greek style, with oil.

> Item: The mountains and rocks done in oil, in different colors.[42]

The side panels, painted by Ambrogio da Predis, were to portray angels with musical instruments, one with a lute, the other with a *lira de braccio.* The artists were to have the painting done by December 8 for the Feast of the Immaculate Conception.

REJECTION BY THE PATRONS

Despite signing a contract that called for specific details painted in the "Greek style," Leonardo did not paint the Virgin under the terms his patrons sought to impose on him. Instead, against a background of rocks, Leonardo painted the Virgin, a single angel, the infant Jesus, and the infant John the Baptist. This was hardly the showy icon the monks had in mind. Leonardo made the painting in a new way, showing the shapes of things by differences in light and shade, with no outlines. In his notebook Leonardo wrote, "The boundary of one thing with another is . . . a mathematical line, because the end of one colour is the beginning of another colour . . . the boundary is a thing invisible."[43] Thus the *Virgin of the Rocks* looked

more realistic because of Leonardo's subtle blending of color boundaries. The beauty and sensitivity of the landscape setting showed his love of nature and his careful study of rocks and plants. All the elements of the grotto in the painting's background were to be found in reality behind Leonardo's mother's house. The background landscape is misty and muted, an example of his aerial perspective. The painting was far richer in feeling, color, and design than anything anyone had ever seen at that time. By painting large areas of shadow the artist released the full brilliance of the pigment in a few well-chosen places.

The monks rejected the work. They wanted their altarpiece to focus attention on the Virgin. Instead Leonardo decided to focus on Jesus and St. John as babies. The monks sued Leonardo for not giving them what they wanted. Leonardo, in turn, sued the monks so they would pay him his money. The two parties fought each other over *Virgin of the Rocks* in court for twenty years. When the case was finally settled, Leonardo and Predis made a second version of the painting, the monks gave them more money to do it, and today there are two versions of the work in existence.

Although the monks of the Immaculate Conception did not appreciate Leonardo's groundbreaking work, the artist had other patrons. While working on *Virgin of the Rocks*, Leonardo was also busy with a commission from Ludovico to paint a portrait of Cecilia Gallerani. The work is now known as *Lady with an Ermine*. Gallerani was the favorite mistress of Ludovico. She spoke fluent Latin, wrote poetry, sang, and was the most powerful woman in his

Leonardo's first version of the Virgin of the Rocks.

court. And in another one of his subtle jokes, Ludovico's mistress was the woman Leonardo used as a model for the Virgin Mary in *Virgin of the Rocks*.

LEONARDO'S ANSWERS TO THE DEADLY PLAGUE

While Leonardo was working on the *Lady with an Ermine*, a deadly plague broke out in Milan, and the artist quickly saw why. Cleanliness, which was so important to Leonardo in his personal life, was sadly

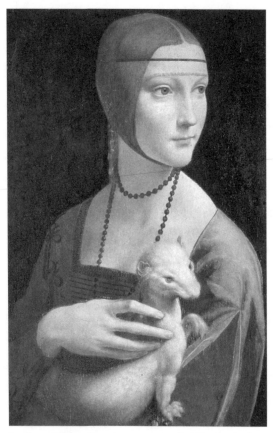

Lady with an Ermine, *a portrait of Ludovico's mistress Cecilia Gallerani.*

Leonardo quickly developed dozens of ideas to clean up the city, and he pressed hard for Ludovico to share his vision of a new Milan. Leonardo designed palace rest rooms with revolving ventilation windows and automatic doors. He also designed public restrooms and roads with drains.

Leonardo saw other solutions to stop the spread of the horrific plague. City planning could prevent the squalid conditions of crowded cities. He proposed that smaller towns, much like modern suburbs, be built at the edges of Milan, all connected to the nearest big river by canals. He told Ludovico:

> Give me the necessary authority . . . and eternal honor will be yours. You will have five thousand houses with thirty thousand inhabitants in ten towns; thus we shall distribute the people now crowded together in huge masses, huddled together like flies on top of each other, filling every doorway with stench and offering an easy prey to pestilence and death.[44]

Leonardo envisioned a city on two levels. The upper zone would be a pedestrian level reserved for nobility, while the lower level would be reserved for the circulation of animals and merchandise, and for the dwellings of shopkeepers, artisans, and other people.

When authorities decided to improve the most squalid and plague-stricken quarters of Milan, Leonardo drew large-scale plans for suburbs that employed the novel concept of splitting up the city, independent of the usual central castle or church. This decentralization would have

lacking all around him. The streets were full of human and animal waste, and even the palaces stunk of human filth, with a heavy overlay of perfume.

Leonardo became very concerned with the disposal of waste. To remove this material in a sanitary way from city streets, the artist devised waste gutters and canals. Leonardo also wanted to provide more lavatories for people, designed for maximum air circulation with seats that would always return to the closed position by means of a counterweight.

CANALS AND CRANES

When the deadly plague hit Milan and killed one-third of the city's inhabitants, Leonardo used his talents as an engineer to plan city improvements that were hundreds of years ahead of their time. The artist sketched plans for canals, water drainage, river dredging, and other town-planning schemes.

To execute these improvements Leonardo turned to the science of leverage to move large weights. He drew powerful cranes, including a twin crane and a traveling crane, for erecting pillars, quarrying stone, and excavating canals. The artist drew automatic release mechanisms which would unhook the load when it was deposited on the ground, and worked on screws, propellers, and cogwheels to transmit power.

To make home life easier, Leonardo designed an air-pressure lift to bring water to the top floors of houses. In addition, he made plans for stoves, ovens, and a mechanical spit-grill run by hot air rising from a fire. He designed lamps that surrounded a flame with a glass bell filled with water, giving off a brighter light. And the artist even invented an alarm clock that awoke a person by pulling on his or her toe.

For the industrial sector, Leonardo invented a cloth-shearing machine which would double or quadruple the output of the duchy's most important industry. Unfortunately for the artist, Ludovico was not interested in Leonardo's inventions, which included designs for stills, rope-making machines, needle-grinding machines, windmills with revolving roofs, and improvements on the design of the printing press. Nor were any of these ideas put into use until they were published 132 years or more after Leonardo's death. Today, Leonardo is one of the most published authors of the Renaissance.

Leonardo's device to excavate canals and pile the dredged-up dirt onto the banks.

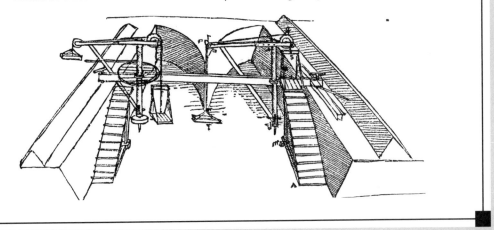

Ludovico commissioned Leonardo to paint the Last Supper *for the dining room of the Santa Maria delle Grazie monastery (pictured).*

turned the area around Milan into a string of separate settlements organized around civil or commercial centers, as modern towns are.

The duke was not interested in Leonardo's plans, which would take his subjects too far out of the reach of his cannons. Instead, the duke of Milan ignored the artist's futuristic vision and fled the city in fear. In less than two years, the plague had killed almost a third of the population.

AFTER THE PLAGUE: LEONARDO PAINTS A MASTERPIECE

In Milan, those who survived the horrors of the plague were living life to its fullest. In the castle of the duke, full of dazzling new fashions and costumes, pomp and excess were given free rein. With the arms laid aside, the duke began a program of renewal in the capital. Some buildings were demolished, others rebuilt and enlarged. Gardens were planted, streets were paved, and walls painted.

In 1492, Ludovico made special plans for the ancient Dominican monastery of Santa Maria delle Grazie located near the Sforza castle. The duke of Milan decided to use the church at the monastery as a burial place for his family and himself. The duke ordered repairs for the church and, around 1495, commissioned Leonardo to decorate the refectory (dining hall) with a mural depicting the Last Supper, a traditional scene for the dining room of monks.

Leonardo chose to illustrate the moment when Jesus, knowing he is going to be crucified, announces to the apostles that he knows one of them will betray him. In the finished work, according to Irma A. Richter, "a wave of feeling seems to pass through the scene as the effect of Christ's calm announcement of His betrayal by one of His disciples is reflected in their agitated attitudes."[45]

The painting was to be on a grand scale, almost thirty feet wide and fourteen feet high. The ceiling lines of the room were to extend into the painted room of the *Last Supper*.

Leonardo made dozens of preparatory drawings for the *Last Supper,* some of which still exist. He drew up the disciples in groups of three and spent hours perfecting the gestures and facial expressions of each character in the painting. Leonardo wandered through the streets of Milan searching for faces, glances, and poses that he could use to express his artistic vision. Finally, in 1495, he had a scaffold set up in the refectory and started to paint.

THE MOST FAMOUS PAINTING

Leonardo liked to work slowly, learning from the painting and changing it as he went. Fresco painting, the traditional technique for painting on walls, was a multistep process in which the outlines of a drawing

(called an underpainting or cartoon) were transferred to damp plaster and painted very quickly, one small area at a time.

Instead, Leonardo experimented with different techniques and materials to bring the picture slowly to perfection. Some days he would mix new glazes and colors, inventing as he went along.

Year after year Leonardo worked at the mural, painting on dry plaster with special glazes and varnishes, then watching his work disintegrate because the room was overly moist and improperly ventilated. The artist began to use a device called a hygrometer to measure the humidity around his moisture-sensitive painting.

Sometimes for weeks, or even months, the artist would not touch the painting at all, but he always returned to it. Then he would work for days without stopping,

The Last Supper *portrays the moment when Jesus tells his apostles that one of them will betray him and captures their varied reactions to this revelation.*

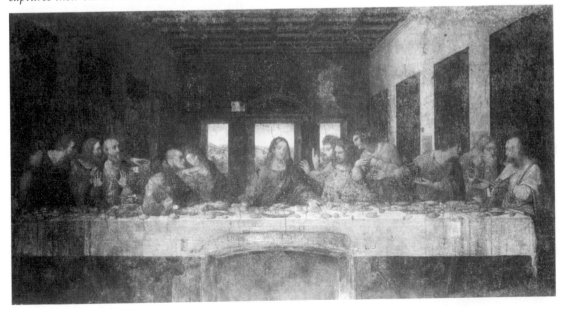

LAST SUPPER RESTORATION

On May 27, 1999, the Italian government finally put one of Leonardo da Vinci's most famous works back on display for public viewing. After a controversial twenty-two-year restoration of the painting, the *Last Supper* emerged from centuries of dirt, decay, and at least nine retouchings over the years. Critics, however, claimed that the restoration was unnecessary and that the painting is now 20 percent da Vinci and 80 percent restoration.

Almost as soon as da Vinci put the finishing strokes to his masterpiece it started to deteriorate, because the artist had experimented with a new painting technique which did not prove successful. A chemical reaction quickly made the paint peel off its base of plaster and lead.

In the 1970s, Italian politicians decided something had to be done to restore one of the most famous paintings in the world. The job was given to Pinin Brambilla, who worked over the painting with a microscope and knife inch by inch to remove the five centuries of re-paintings and dirt. Ms. Brambilla used special chemicals to remove the old paint that had been added by others.

But Brambilla also removed Jesus' red beard as well as the faces and feet of some of his twelve disciples. One follower who has been brunette for centuries is now blond, and other large areas are missing entirely. But according to Giuseppe Basile, an art historian involved in the restoration, the changes to the painting were made in the five hundred years since Leonardo finished the work and were not the original work of the artist.

morning until night, barely halting to eat, thinking of nothing else. Suddenly he would put down his brushes and stand silently for a long time, looking at the picture. Days later he would come back to the work and just study it for hours, sometimes adding a few brush strokes before leaving.

As Ariane Ruskin wrote: "The result was one of the great paintings of all time. Again we have the meticulously perfect composition of a Leonardo: all lines lead to the right eye of Christ, Himself a great triangular form of sadness and wisdom."[46] The light in the painting seems to come from the left, as if lighted by the window in the left wall of the dining room. The figures in the painting are larger than life and above eye level. And, according to author Bernard S. Myers: "The thirteen personages of Leonardo's *Last Supper* are . . . studies of mankind, humanistic and sympathetic portraits of anger (Peter), love (John), cupidity (Judas), and other universal emotions that

the painter has tried to epitomize in attitude and gesture."[47]

Unlike most of Leonardo's works, the mural was exhibited publicly and seen by a large number of people. This brought the artist widespread fame and allowed him to become one of the leaders of Italian painting. Before long artists came from all over Europe to discuss, copy, and study the painting. Richard Friedenthal writes:

> The *Last Supper* became the best known picture of the Christian world. It is significant of Leonardo's inexplicably complex and contradictory nature that he, though certainly not orthodoxly pious, if not downright pagan, supremely interested in the working of nature, mathematics, and anatomy, should have created this valid artistic monument to a faith from whose externals he always remained remote.[48]

For centuries, the *Last Supper* suffered the ravages of time, the elements, bad restorations, and neglect. In the seventeenth century, careless monks enlarged a door through the center of the picture, cutting off Jesus' legs and feet. In the late eighteenth century, when the French conqueror Napoleon occupied Milan, his soldiers used the room as a stable and amused themselves by throwing stones at the picture. Napoleon so respected Leonardo, however, that he took some of the artist's manuscripts back to France.

During World War II, the church was bombed by allied planes, but the painting was left standing. Recently, the *Last Supper* was carefully renovated with modern techniques, and the mural, now clean and bright, still inspires awe and reverence for Leonardo's genius.

4 The European Master

Leonardo da Vinci finished the *Last Supper* in the autumn of 1497, and with the completion of this task he was established as a master of masters. He was now famous all over Italy, and held an especially elevated status in Milan. The artist looked forward to a period of leisure and uninterrupted study.

For Leonardo, the 1490s were exciting years marked by growing fame. He was the court painter, sculptor, and master of ceremonies, but he was so much more. During this period, Leonardo dedicated much of his time to research in the fields of anatomy, hydraulics, and the nature of flight. But a series of disasters and tragedies would soon send the artist on a different path than he might have envisioned while adding the final brushstrokes to the *Last Supper*.

TRAGIC DEATHS

Around 1496 or so, Leonardo lost someone who was very dear to him, his mother Caterina. Soon after, there were two more deaths that affected Leonardo and everyone else in Milan. On November 23, 1496, Bianca Sforza, Ludovico's fourteen-year-old daughter and the pride of his life, died of a fever. Ludovico was overwhelmed with grief and the court of Milan plunged into a period of deep mourning.

A little over a month later, Ludovico held an extravagant New Year's celebration to help him get over the death of Bianca. Beatrice Sforza, Ludovico's wife, who was eight months pregnant, danced all through the night. At dawn, she had a miscarriage and died. Ludovico, who relied upon his wife for advice, was inconsolable. After the funeral, he locked himself in a room hung with black draperies, stayed awake for days at a time, screamed, cursed, prayed, sang hymns, and finally fell into a stupor of grief. For weeks, he acted as if he were insane.

After the period of intense mourning, the duke suddenly became extremely religious and strangely quiet. He began to attend church every day and dine with the Dominican friars in their refectory. He bestowed upon them gifts of astounding wealth, including jewels, silver, and the income from one of his private estates in Vigevano.

For Leonardo, Ludovico's behavior was becoming increasingly difficult and dangerous. According to Payne:

Like all tyrants, [Ludovico] was unpredictable, and in these days he was more unpredictable than ever. He was wracked by grief, and at the same time intensely aware of the uncertainties of his position. Prices were rising, the people were murmuring against him, the days of his great popularity were over. He made great plans and nothing came of them; ordered works of art and forgot to pay for them; and continued to settle estates on the Church and his mistresses. His extravagances were ruining the state.[49]

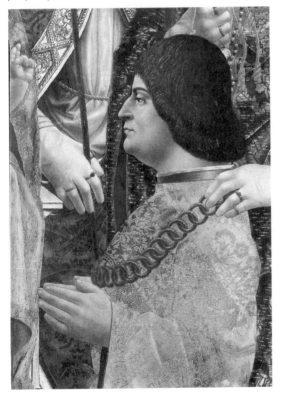

By 1497, Ludovico Sforza's popularity among the people of Milan was waning.

Meanwhile, Leonardo was also spending huge sums of money. Appeals to the duke or his accountants for moneys due to him went unanswered. On at least one occasion, Leonardo wrote a letter to Ludovico complaining, "I had still to receive two years' worth of [my] salary."[50] This note was found ripped .to pieces, and was probably never mailed. At another time, Leonardo reminded the duke that he was in great want and that his poverty had interrupted work that Ludovico had assigned to him.

Leonardo, however, was exaggerating his poverty. He was gaining income from his inventions, for land surveys he made, and paintings he had created for other patrons. He continued to live in the sumptuously furnished apartments set aside for him by the duke.

LEARNING TO FLY

Leonardo's apartment was not accessible to the general public, and the surrounding apartments were occupied by high officers of the state. So it was on the roof of his apartment, in great secrecy, that Leonardo began to experiment with his first models of flying machines.

The idea of flying had occupied Leonardo's thoughts since his adolescence. His anatomical studies of bird wings appeared in his notebooks when he was painting *Adoration of the Magi*. From 1482 onward, his notebooks explore the possibilities of humans soaring through the air like birds of prey. In the early 1490s, he sketched plans for several flying

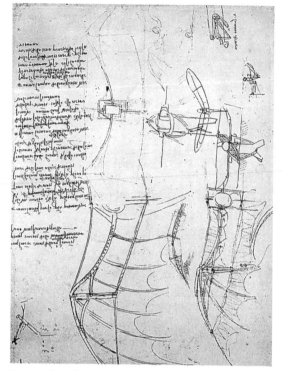

Leonardo's drawing of wings for his ornithopter, a flying machine that mimicked the flapping of a bird's wings.

machines based on the wing structure of birds and bats. In later years his ideas utilized the propeller, the helicopter rotor, and finally the glider. To aid his study, Leonardo studied the way birds glide and float, how their tails help them steer, and how their weight is balanced.

In the *Codex Atlanticus*, Leonardo made a note to himself to study birds' wings and apply the physics to humans to enable flight:

> You will study the anatomy of the wings of a bird, together with the muscles of the breast which are the movers of these wings. And you do the same for man in order to show the possibility

... in man to sustain himself in the air by the flapping of [artificial] wings.[51]

Rather than try to reconstruct the feathered wing of a bird, Leonardo finally decided to model his flying machine on the webbed wings of the bat. He wrote: "Remember that your flying machine must imitate no other than the bat, because the web . . . is what . . . gives . . . strength to the wings."[52]

In his pursuit of the perfect man-made wing, Leonardo dissected various flying creatures. He also sketched flying machines of many shapes and sizes, some of which used a system of strings and pulleys that would bend and flap wings. He sought out lightweight materials, such as silk, gauze, canvas, or leather, to construct his wings. The chassis of the machine was to be made of thin pine or reeds with springs made from steel or animal horn.

On January 2, 1496, Leonardo went so far as to write that he was ready to take a test flight off the roof of his apartment building, an idea he apparently abandoned. Bramly continues the story:

> Under Leonardo's pen, the *ornitottero* [flying machine] took many shapes, successively looking like a canoe with a balancing mechanism, an indoor rowing machine, a large butterfly with four wings, or a [gourd] shell crossed with a windmill. It was variously equipped with pedals, a rudder, stirrups, a sail, handles, a harness, a gondola, platforms, steering cables, and a retractable undercarriage made up of ladders and buffers.

Full of faith, Leonardo spent endless hours on his invention. Others might have tried to fly before him, but no one had pursued this dream with such patience, ingenuity, daring, and tenacity.

He must have given up in the end the idea of jumping from the roof of [his apartment in] the Corte Vecchia. . . . Perhaps he used the roof only to test the load his wings could bear, or to try out his models. Prudently, he decided: "You will experiment with this machine over a lake and you will wear attached to your belt a long wineskin [as a sort of life buoy], so that if you fall in, you will not be drowned."[53]

LEAVING MILAN BEHIND

In April 1499, Ludovico granted Leonardo a piece of land outside of town, planted with vines. Either the duke was satisfied with Leonardo's work, or his royal coffers were so exhausted that he had to pay his court artist with land. In any event, while Leonardo was tinkering in his studio, planning to build a home and dreaming of flight, destructive political changes were stalking the duke of Milan.

The new king of France, Louis XII, had formed a secret alliance with Venice against Milan. Ludovico, fearing a French invasion, began to hire mercenary soldiers and arm his forts. The French soon crossed the Alps and began their invasion of Italy. As they approached Milan, Ludovico failed to rally the city to come to his defense. The duke's generals deserted him after a mob of peasants lynched his treasurer.

The panic-stricken duke sent his children and the remains of his fortune to Germany, and later escaped to Switzerland. On September 14, 1499, Milan surrendered to the French without a single shot being fired. On October 6, Louis XII made his triumphal

King Louis XII (pictured) of France invaded Milan, forced Ludovico to flee, and seized control of the city in 1499.

LEONARDO'S BOOKS

In a single month Leonardo might work on a painting, design a cannon, ponder methods of flight, and plan a canal through Florence. The artist owned a wide variety of books during this intellectually stimulating period of his life, and he jotted down an inventory of his reading material in the Codex Atlanticus. *It was reprinted in Ivor B. Hart's* The World of Leonardo da Vinci. *When Leonardo left Milan in 1499, he took with him the following:*

"Book on *Arithmetic* (Abbaco)

Flowers of virtue (a medieval bestiary) [allegorical descriptions of real or imaginary animals]

Pliny (*Natural History*)

Lives of Philosophers (Diogenes Laertius)

The Bible

Lapidary [relating to precious stones]

On Warfare (Robertus Valturius)

Epistles [letters] of Filelfo

The First, the Third, the Fourth Decades [of the history of Rome] (Livy)

On the preservation of health (Ugo Benzo of Siena)

Cecco d'Ascoli's *Acerba* (a fourteenth-century encyclopaedia)

Albertus Magnus (Aristotelian philosophy and science)

Guido on Rhetorics (probably the *Retorica nova* by Guidotto of Bologna)

Piero Crescentio (on agriculture)

Cibaldoni's *Miscellanea* (a Latin version of a treatise on health by the Arabian [physician] Rhazes)

Quadriregio (The Four Realms—a Religious Scientific Poem by the Dominican Federigo Frezzi)

Aesop (Fables)

Donatus (a short Latin syntax)

Psalms

Justinius (History)

On the Immortality of the Soul (dialogue by Francesco Filelfo)

Guido (probably a book on astronomy by Guido Bonatti)

Burchiello (sonnets)

Doctrinale (a vernacular translation of "Doctrinal de Saprenci" by Guy de Roy)

Driadeo, Morgante, [and] *Petrarch* [by Lucal Palci]

Jehan de Mandeville (book of travels)

On honest recreation (by Bartolomeo Sacchi)

Manganello (a satire on women)

The Chronicals of Isidore (a history to A.D. 615 by Isidore of Seville)

The Epistles of Ovid

The Jests of Poggio

Chiromancy [palm-reading]"

entry to the city. As the days wore on, the French began looting the city and indiscriminately killing the people, including several of Leonardo's friends.

As Leonardo prepared to abandon Milan, he filled his notebooks with lists of items to pack, such as books, reams of paper, bedding, and a stove—and tools to sell, including the scaffolding planks used to paint the *Last Supper*.

Thus ended an eighteen-year chapter in the life of Leonardo da Vinci. As the fifteenth century came to a close, Leonardo, having put his affairs in order, sent most of his savings to a bank in Florence. He then set off for a trip through Italy, stopping first in Mantua, then in Venice.

The invading French troops were quick to notice the clay model of the *Great Horse* that Leonardo had left behind. One day a group of the king's archers, in an act of vandalism characteristic of armies of the times, used the huge statue for target practice. That day, the largest and possibly most finely sculptured horse in history was destroyed.

THE ROAD BACK TO FLORENCE

Leonardo only lingered in Mantua long enough to draw up a chalk profile of Isabella d'Este, Beatrice Sforza's older sister. In early 1500 he arrived in Venice, where he made a great impression on the artists in that city of art. Venice at this time was threatened by the Turkish Ottoman Empire, and Leonardo briefly revived his ambitions as a military engineer with plans for a dam to flood the river in the Isonzo

Valley to prevent a Turkish invasion. Before long, Venice signed a peace treaty with the Turks, and Leonardo decided to leave Venice and return to Florence.

By April 1500, the forty-eight-year-old Leonardo was back in the city where he had spent his time as a young man and had mastered art. But the Florence Leonardo returned to had changed as much as the now gray-haired artist. The city had turned from a gay and colorful metropolis into a gloomy place of contemplation and repentance.

In 1494, the Medici had been exiled and a new leader arose—the Dominican friar Girolamo Savonarola. The new leader had

Girolamo Savonarola, a Dominican friar and leader of Florence from 1494 to 1498.

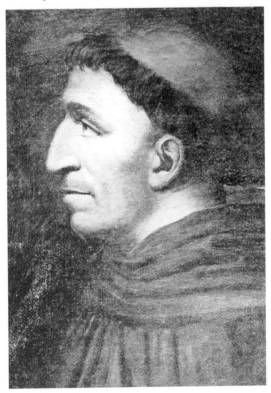

become very popular with the common people because of his criticism of the moral laxity of the upper classes. In addition, Savonarola had made several terrifying prophecies of doom, some of which came true. With the Florentines stunned into submission, Savonarola ordered the children of the town to build great "bonfires of the vanities" to burn musical instruments, playing cards, antiques, books, mirrors, and women's jewelry. He also ordered the burning of hundreds of works of art, possibly including several made by Leonardo.

In 1498, however, a backlash arose against Savonarola's theocratic dictatorship, and the Dominican friar was tortured, hanged, and burned at the stake as a heretic in the square in front of the Palazzo della Signoria after a savage uprising of the popular party. A new monumental style of

LEONARDO'S NAVAL WARFARE

Venice is a city by the Adriatic Sea that is traversed by dozens of canals. When Leonardo visited the city in 1500, he had been thinking about schemes for waging naval warfare for several years. Since Venice was under threat of attack by the Turkish navy, Leonardo proposed to the Venice Senate a plan for underwater raids against the Turks.

Leonardo envisioned sending underwater divers into combat against enemy ships. The divers would wear glass goggles and would carry wineskins full of air to allow them to breathe under water. The divers would sink enemy ships by drilling large holes in their hulls beneath the waterline.

Leonardo also proposed building a fortified one-hundred-foot-long "ramming boat" in which rowers would use long oars to gain enough leverage to pound the sharpened hull of the ramming boat into an enemy ship. He also devised lifesaving shields, floats for walking on water, bulletproof vests, chainmail for underwater combat, and a one-man submarine.

Leonardo did, however, question the morality of designing such implements of war. In *The Notebooks of Leonardo da Vinci*, he wrote that he could describe in detail many ways that would allow people to stay underwater for long periods, but "I do not publish or divulge these by reason of the evil nature of men who would use them as means of destruction at the bottom of the sea, by sending ships to the bottom, and sinking them together with the men in them."

art was emerging from the ashes, and Leonardo's new work was to be part of it.

VIRGIN AND CHILD WITH ST. ANNE

Upon his return, Leonardo spent his time looking for lodgings—and a new patron. The artist saw his father once again, now seventy-four and living in a house with his large extended family.

The monks of the Servite monastery (whose legal affairs were managed by Leonardo's father) had ordered an altarpiece from the artist Filippino Lippi, who modestly withdrew when he learned Leonardo had returned. Leonardo moved into the monastery with the monks, but he was not immediately motivated to paint. Instead, he studied geometry with his friend Luca Pacioli.

Finally, in 1501, the monks persuaded Leonardo to exhibit his black-and-white cartoon of the *Virgin and Child with St. Anne*. As Vasari writes, the cartoon

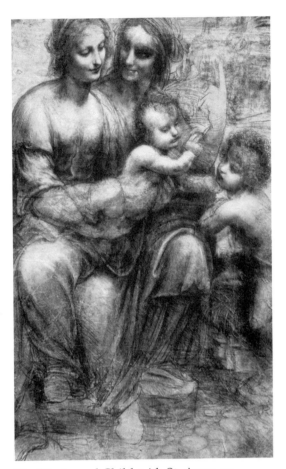

The Virgin and Child with St. Anne, *an unfinished black-and-white cartoon of St. Anne, Mary, Jesus, and St. John.*

not only filled every artist with wonder, but, when it was finished and set up in the room, men and women, young and old, flocked to see it for two days, as if it had been a festival, and they marvelled exceedingly. The face of the Virgin displays all the simplicity and beauty which can shed grace on the Mother of God, showing the modesty and humility of a Virgin contentedly happy, in seeing the beauty of her Son, whom she tenderly holds in her lap. As she regards it the little St. John at her feet is caressing a lamb, while St. Anne smiles in her great joy at seeing her earthly progeny [St. Anne was believed to be the mother of Mary] become divine, a conception worthy of the great intellect and genius of Lionardo.[54]

The fluid movement of the lofty lifelike figures must have seemed a revelation to the artists of the day. There is little separation between the grandmother, the mother, and the son; they are fused into a

single monumental form. The Child is on their laps, leaning toward John the Baptist, the patron saint of Florence.

The common people of Florence were moved by this strange picture, so different from any they had seen before. Only Leonardo had lost all interest; he was working only at geometry. The painting of St. Anne hangs in the Louvre today in Paris, unfinished. Leonardo worked on it sporadically for eight or nine years, but he never completed the landscape or the robes. Apparently even some of this work was delegated to his pupils.

APPOINTED MILITARY ENGINEER

Seemingly at loose ends, Leonardo traveled around Italy in search of a prince who shared his tastes and might become his patron. In 1502, Leonardo thought he found that patron in the person of the twenty-seven-year-old Cesare Borgia, who offered

him the post he had always dreamed of—military engineer.

Borgia, a Roman whose name today is associated with cruelty, deception, and lust, was the illegitimate son of Pope Alexander VI. He was rumored to have had an affair with his sister Lucrezia and later arranged her marriage to other princes whom he soon killed with noose and dagger for his own personal gain. Borgia was also said to have killed his own brother in order to replace him as captain-general of the armies of the church. Even if these rumors were true in all respects, however, Borgia's worst crimes differed little from the excesses of the other tyrants of his day.

Leonardo and Borgia seemed to have taken an instant liking to each other. As two children born out of wedlock, both had relied on their intelligence and independence to rise to the top of their respective fields. Perhaps, too, Leonardo's bold visions meshed well with the audacity of the

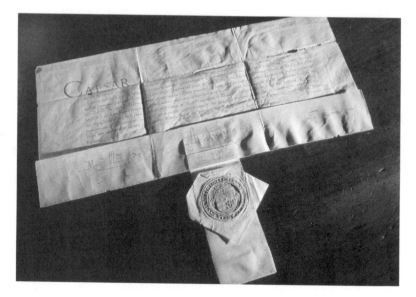

Cesare Borgia's 1502 commission for Leonardo to become his military engineer.

LEONARDO'S ROBOT

Around 1495, Leonardo designed and possibly built the first humanoid robot. It is described on the website maintained by the Institute and Museum of the History of Science in Florence, Italy.

"The robot [was] an outgrowth of his earliest anatomy and [studies of the motion of the body]. . . . This armored robot knight was designed to sit up, wave its arms, and move its head via a flexible neck while opening and closing its anatomically correct jaw. It may have made sounds to the accompaniment of automated drums. On the outside, the robot is dressed in a typical German-Italian suit of armor of the late fifteenth century. This robot would influence his later anatomical studies in which he modeled the human limbs with cords to simulate the tendons and muscles.

The robot consisted of two independent systems: three-degree-of-freedom legs, ankles, knees, and hips; and four-degree-of-freedom arms with articulated shoulders, elbows, wrists, and hands. The orientation of the arms indicates it was designed for whole-arm grasping, which means that all the joints moved in unison. A mechanical, analog-programmable controller within the chest provided power and control for the arms. The legs were powered by an external crank arrangement driving the cable, which was connected to key locations in the ankle, knee, and hip. . . .

Leonardo's paradigm has been the guiding inspiration [for modern-day] work on anthrobots [robots with a humanlike form]. Miniature muscles replace Leonardo's cable system and are mounted with sensors to detect position and forces. . . . [This design] has culminated in the electric 43-axis Robotic Surrogate built for NASA Johnson Space Center and intended to service Space Station Freedom. Thus, Leonardo's vision reaches beyond the confines of our planet to explore the universe."

prince. Paintings of Borgia portray him as proud and handsome, full of strength and energy. And as Bramly writes, "The painter needed the protection of such men: enterprising, powerful, and strong."[55]

Leonardo went right to work for Borgia designing new multiple-shot cannons and engines of war. He drew up plans for several weapons which held a striking resemblance to those used during the

American Civil War almost 360 years later. Using plans from other inventors, Leonardo improved on the multibarreled machine gun and field cannon, making them lighter and faster. He designed mortars like those not in use until the nineteenth century. In addition Leonardo designed cannons for naval vessels that would fire shrapnel-filled fireballs more deadly than machine guns.

Leonardo also invented an ingenious steam cannon, loaded with a screw apparatus, that he called the *Architronito,* the *Arch-Thunderer,* possibly after the Greek mathematician Archimedes (287–212 B.C.) whose screw design Leonardo modified. In *The Inventions of Leonardo da Vinci,* Charles Gibbs-Smith and Gareth Rees comment on this futuristic weapon.

> Since Leonardo quoted figures of how far the *Architronito* would drive a cannonball of given weight, it is possible that one was actually built, many centuries before the steam cannon of the American Civil War. Certainly the method shows a way of putting the expansive power of steam to work centuries before the steam engine.[56]

"OUR MOST EXCELLENT ... ENGINEER"

Borgia, for his part, put aside many of Leonardo's inventions as impractical or unbuildable. But in August 1502, Borgia issued a patent of authority—a letter granting Leonardo access to all his forts. It read:

> To all our lieutenants, castellans, captains, *condottieri,* officials, soldiers, and subjects. We constrain and command that the bearer, our most excellent and well-beloved servant, architect, and engineer-in-chief, Leonardo Vinci—whom we have appointed to inspect strongholds and fortresses in our dominions to the end that according to their need and his counsel we may be enabled to provide for their necessities—to accord a passage absolutely free from any toll or tax, a friendly welcome both for himself and his company; freedom to see, examine and take measurements precisely as he may wish; and for this purpose assistance in men as many as he may desire; and all possible aid and favor. It is our will that in the execution of any works in our dominions every engineer will be bound to confer with him and follow his advice.[57]

For about a year, Leonardo made a dozen visits for Borgia, inspecting fortresses, villages, and cities. During his travels Leonardo combined his skills as a painter with his knowledge of military engineering as he drew up six detailed maps of central Italy. These maps—the most extensive ever made at the time—showed features of terrain (such as valleys, mountains, and streams) that would be helpful to the army.

At this time, measurement was not a very exact science, and the length of the unit of measurement known as the *braccio* (arm's length) varied between one Italian city and the next. In his endeavor as Bor-

gia's mapmaker, Leonardo drew the first accurate scale-maps ever executed. By applying his painter's rules of perspective to his measurements of distance, Leonardo was able to survey land and draw maps to scale.

LEONARDO THE SPY?

There is never any mention of Leonardo taking part in military operations, and his notebooks indicate that he examined as many libraries and works of art as he did fortresses. Yet some historians speculate that Leonardo might have been spying on Borgia for the rulers of Florence.

Raymond S. Stites explores that possibility in *The Sublimations of Leonardo da Vinci:*

> There seems to be some indication that [Borgia's] father, the Pope, also had his eye upon Florence. I have often wondered if perhaps Leonardo was urged by his father's friend, Piero Soderini, to join Borgia . . . in order to inform the head of the Florentine state what Borgia's plans might be. . . .
>
> Leonardo was [also] in an excellent position to steer Borgia away from Florence, whose defenses at the time were weak. . . . Leonardo could hardly have failed to see that Borgia was a bloody, fickle tyrant, anxious not only to capture the cities for the

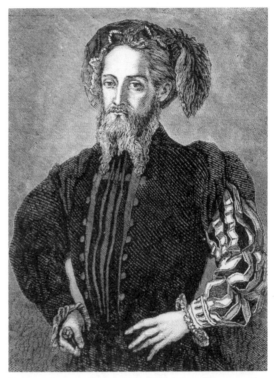

Roman tyrant Cesare Borgia (pictured) pursued his quests for power and territory with the help of Leonardo's weapons, maps, and advice as military engineer.

> Church but plotting, eventually, to make himself pope.[58]

All of this was quickly rendered irrelevant when Leonardo learned that Cesare Borgia was near death in Rome, his empire was collapsing, and an enemy of his family was about to mount the papal throne. Will Durant succinctly describes the artist's position: "Once more, Leonardo, his new world of action fading before him, turned back to Florence."[59]

5 Artistic and Personal Battles

Leonardo returned to Florence in April 1503 and, at the request of the city fathers, began to work on a mural in the Council Chamber at the Palazzo della Signoria. The subject was the Battle of Anghiari, a victory of Florence over the Milanese that had taken place in 1440.

The wall on which Leonardo was to make the painting was three times larger than that of the *Last Supper*. Leonardo set up his studio in the Hall of Popes in the Monastery of Santa Maria Novella and set to work on a full-scale drawing of the painting. The painting was to be made up of groups of soldiers in battle in front of a panoramic landscape showing the valley where the battle took place.

THE BATTLE OF THE MASTERS

Another battle mural was commissioned by the men who hired Leonardo. This painting, called *Battle of Cascina*, was given to a young painter named Michelangelo. Although only half the age of Leonardo, at twenty-nine Michelangelo Buonarotti was already famous.

The two artists who were considered the best in the world set about completing their sketches for their respective murals. Durant describes the public fervor surrounding such an artistic duel:

> The alert citizens followed the progress of the work as a contest of gladiators; argument rose excitedly on the rival merits and styles; and some observers thought that any definite superiority of one picture over the other would decide whether later painters would follow Leonardo's bent toward delicate and subtle representation of feeling, or Michelangelo's penchant for mighty muscles and demonic force.[60]

When Leonardo's full-scale cartoon was shown, it was admired by all who saw it. Michelangelo's cartoon was also highly praised. But in an odd quirk of fate, the two paintings were never completed. After finishing his full-scale drawing, Michelangelo accepted a call to Rome to work for Pope Julius II. And, according to Vasari: "There was no love lost between [Leonardo] and [Michelangelo], so that the latter left Florence owing to their rivalry."[61]

After painting the central battle scene of the *Battle of Anghiari*, Leonardo abandoned his mural when he was urgently called to Milan by Charles d'Amboise, the powerful

French governor of that city, who wanted him to draw a cartoon of St. Anne in colors. The great competition between Michelangelo and Leonardo was left an incomplete mess, and the city fathers of Florence were angry and upset with Leonardo.

Although the paintings were never finished, both became the most influential works of their day. For decades to come, artists came from all over the world to study Michelangelo's cartoon and Leonardo's central battle scene.

CALLED TO MILAN

While Leonardo was working on the battle scene, his father died. The painter recorded the event in his notebook: "On 9 July 1504, a Wednesday, at seven o'clock, died Ser Piero, notary to the Palace of the Podestat, my father . . . aged eighty years, leaving ten sons and two daughters."[62] Although the painter does not record his emotions in the note, historians conclude that Leonardo must have been very upset to make several obvious errors when he wrote down the message: July 9 was in fact a Tuesday, and his father was seventy-eight, not eighty.

By 1506, Leonardo had returned to Florence to continue work on the *Battle of Anghiari*. In April he was called away again by Charles d'Amboise, who wrote to the leaders of the city requesting that Leonardo return there for three months to do some

DESCRIBING THE BATTLE SCENE

The Notebooks of Leonardo da Vinci *contain a long, vivid description of the battle scene Leonardo would paint for the* Battle of Anghiari. *He wrote about the* "smoke of artillery mingling in the air with the dust and tossed up by the movements of the horses." *In addition the artist wrote that the mural would show:*

"[A] horse dragging the dead body of his master . . . the skin above [his] brows furrowed in pain . . . and the teeth apart as with crying out and lamentation. . . . Others must be represented in the agonies of death grinding their teeth, rolling their eyes, with their fists clenched against their bodies and their legs contorted. Some might be shown disarmed and beaten down by the enemy, turning upon the foe, with teeth and nails, to take an inhuman and bitter revenge. . . . Some maimed warrior may be seen fallen to the earth, covering himself with his shield, while his enemy, bending over him, tries to deal him a deathstroke. . . . And there must not be a level spot that is not trampled with gore."

work. The Florentines were unhappy with the request because the *Battle of Anghiari* was not even close to completion. But France was a powerful ally and d'Amboise a powerful man who could not be refused.

After Leonardo had been in Milan for three months, d'Amboise wrote another letter saying that Leonardo's leave of absence would be extended another three months. When Leonardo had not returned to Florence at the end of September, the city fathers wrote d'Amboise a letter stating:

> Leonardo has not comported himself toward this Republic as he should have done, for he has accepted a goodly sum of money and has done very little of the great work he should have done, and . . . we demand that there should be no more extensions, for his work must satisfy the general body of our citizens and we cannot dispense him from his obligations without failing in our duty.[63]

Although Leonardo returned to Florence in early December, d'Amboise told the city fathers that he wanted the painter to return again to Milan at the earliest moment.

The importance of Leonardo da Vinci at this time was underscored by letters exchanged between these powerful heads of state. This episode not only shows Leonardo's fame but the position of artists in society during the High Renaissance. In the early years of the Renaissance, painters were considered craftsmen, like carpenters and shoemakers. Driven in part by Leonardo's fame, artists had become sought-after companions of kings and nobility.

The Unfinished Battle

Leonardo is said to have been secretly amused by verbal battles between Milan and Florence over who would claim his talents. In the summer of 1505, the artist returned to the *Battle of Anghiari*. After finishing touches had been added to the central fight scene, however, the painting began to fall apart when the plaster on the wall rejected the pigments mixed in oil. According to Vasari:

> Thinking he could paint on the wall in oils, he made a composition so thick for laying on the wall that when he continued his painting it began to run and spoil what had been begun, so that in a short time he was forced to abandon it.[64]

What Vasari did not write was that when the paint refused to set properly, the artist tried to dry it with fire. The colors in the upper half of the painting not reached by the fire ran down and ruined the lower part of the painting.

The deteriorating *Battle of Anghiari* remained on the wall until 1563, when Leonardo's biographer Giorgio Vasari—who was also an artist—was employed to paint his own battle scene over Leonardo's. The incomplete *Battle of Anghiari* added to the legend that Leonardo never finished any work that he began. The cartoon was completed and the colors of the central scene were painted in. The mural re-

The Battle of Anghiari *on display in the Palazzo Vecchio in Florence is the work of Vasari, who in 1563 was commissioned to paint over Leonardo's battle scene.*

mained unfinished, deteriorating, with large areas of color melted and running down the wall, but it was not a complete ruin. Several copies of it were made and it was widely admired for sixty years before Vasari was commissioned to paint over it.

Leonardo's battle scene probably still survives under the painting done by his biographer. In modern times, scientists have attempted without success to locate the painting under Vasari's by means of sensitive sonar detectors.

THE *MONA LISA*

During the time between 1503 and 1506 when Leonardo was working on the *Battle of Anghiari*, some historians believe he also began painting the most famous and celebrated portrait in the world, the *Mona Lisa*.

The model's famous three-quarters pose, her hint of a smile, and the misty landscape behind her would become the classic portrait formula used by painters and photographers for centuries to

come. According to *Mona Lisas* by Mary Rose Storey,

> The pose of the *Mona Lisa* was considered innovative in Leonardo's time and was widely imitated. It is a refined variation of the classical *contrapposto,* an Italian word often applied to the pose in which one part of the body twists in a different direction from the rest.[65]

The true history of the *Mona Lisa* is as mysterious as the subject's smile. The oldest surviving description of the painting, written by Vasari, is enthusiastic, but the writer never actually saw the painting—it was in France when he wrote Leonardo's biography. Vasari did, however, visit Francesco Melzi, Leonardo's heir who was also his apprentice since 1507. Melzi, no doubt, clarified the facts surrounding the *Mona Lisa* before 1568, when Vasari wrote:

> For Francesco del Giocondo, Lionardo undertook the portrait of [Mona] Lisa, his wife, and left it incomplete after working at it for four years. . . . This head is an extraordinary example of how art can imitate Nature, because here we have all the details painted with great subtlety. The eyes possess that moist lustre which is constantly seen in life, and about them are those livid reds and hair which cannot be rendered without the utmost delicacy. The lids could not be more natural, for the way in which the hairs issue from the skin, here thick and there scanty, and following the pores of the skin. The nose possesses the fine delicate reddish apertures seen in life. The opening of the mouth, with its red ends, and the scarlet cheeks seem not colour but living flesh. To look closely at her throat you might imagine that the pulse was beating. Indeed, we may say that this was painted in a manner to cause the boldest artists to despair. Mona Lisa was very beautiful, and while Lionardo was drawing her portrait he engaged people to play and sing, and jesters to keep her merry, and remove that melancholy which painting usually gives to portraits. This figure of Lionardo's has such a pleasant smile that it seemed rather divine than human, and was considered marvellous, an exact copy of Nature.[66]

Vasari states that Mona Lisa was the fourth wife of Francesco del Giocondo, a wealthy Florentine silk merchant. She had one child who died in infancy and was about twenty-six or twenty-seven in 1505 when the painting was nearing completion. Leonardo never gave a title to the painting, and since Mona Lisa was Giocondo's wife, in Italy the painting is called *La Gioconda,* in France, *La Joconde,* and in English-speaking countries, *Mona Lisa.*

While Vasari says that Leonardo employed "jesters to keep her merry," others believe that Mona's smile was one of the puns that Leonardo was known to love so well. In Italian, Mona's married name, Giocondo, means cheerful, joyous, and happy. The artist might have been making a pun of Mona Lisa's married name when he gave her that subtle smile.

THE MYSTERIOUS MONA

Hundreds of scholars, researchers, and historians have pored over ancient manuscripts in remote libraries to discover what they can about the *Mona Lisa*, because its early history is so obscure. The picture, which is painted on a thirty-by-twenty-one-inch poplar panel, is unsigned and undated. Unlike most of Leonardo's other works, there are no reference sketches or preliminary drawings of the painting in the artist's notebooks. It is generally agreed that Leonardo painted the portrait near the end of his career, when he was over fifty years old.

In spite of what Vasari has written, throughout the centuries, about a dozen different women have been named as the model for the *Mona Lisa*. It is possible she is Pacifica Brandano, the mistress of Giuliano de' Medici, or one of the mistresses of Charles d'Amboise. Others have suggested she is Costanza d'Avalos, the duchess of Francavilla. Some people have suggested that there was no model at all, that Leonardo was simply painting his version of the ideal woman.

Others have long contended that the Mona was Leonardo himself, with his beard and wrinkles removed. This theory was put to the test in 1998 when a graphic artist named Lillian Schwartz applied computer-based technology to the mystery. Schwartz took Leonardo's famous self-portrait, reversed the image and scaled it to the *Mona Lisa* on a computer screen. She found that the noses, mouths, foreheads, cheekbones, eyes, and brows all lined up. Schwartz concluded that Leonardo started with a female model, and when she was no longer available, the artist simply used his own face.

Many questions remain unanswered about the most recognizable painting in the world: If the painting really was commissioned by Francesco del Giocondo,

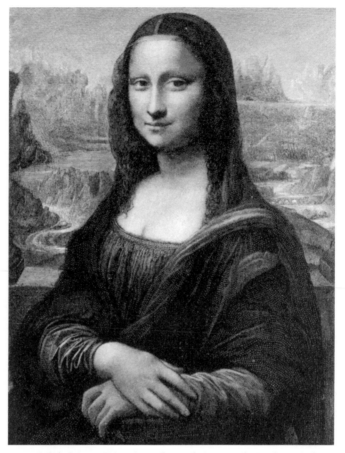

Leonardo's Mona Lisa *is perhaps the most admired, copied, and analyzed painting in the world.*

LEONARDO ADOPTS AN APPRENTICE

Sometime during the years that Leonardo was working on the *Mona Lisa,* his travels brought him into contact with Francesco Melzi, a Lombard aristocrat about fifteen years old, whose parents owned an estate in Vaprio d'Adda, about twenty miles east of Milan. The young man and the aging artist quickly became friends.

Young Francesco announced to his family that he wished to become Leonardo's pupil and learn the art of painting. Although it was unprecedented for a highborn son of a good Lombard family to soil his hands with paint, Melzi's family did not object.

From that time onward, Francesco Melzi never left Leonardo's side. Melzi nursed Leonardo when he was ill, handled his studio affairs, took notes and dictation, and later put Leonardo's notebooks into order after the artist died. Melzi also exhibited talent with the brush, and several of his paintings now hang in European art museums.

It is likely that Leonardo felt a need for a son and an heir in his old age, someone to whom he could pass along his vast store of knowledge, convictions, and beliefs. Melzi was legally adopted by Leonardo in 1508, and the two were inseparable until Leonardo's death in 1519.

why did Leonardo not deliver it and collect payment? Did Mona Lisa die before the painting was finished, so that the grieving husband no longer wanted it? Did Leonardo fall in love with the painting which depicts his dream woman (possibly his mother Caterina) in front of a fantastic landscape? Were there, in fact, two *Mona Lisas,* one given to Giocondo and another kept by the artist? And Vasari says the painting was left unfinished, but the *Mona Lisa* hanging in the Louvre appears to be complete. Were the final touches added by another artist?

The clothing and hairstyle of the model in the portrait add to the mystery, according to Mary Rose Storey, who wrote:

> The dress is unusually plain for a gentlewoman and does not seem to conform with current fashion. The hair is not artfully styled but, instead, simply parted in the middle and hanging down in tightly coiled curls. And there is not a single piece of jewelry which could denote wealth or social position. Only the crossed hands seem to signify upperclass politesse.[67]

Above all, *Mona Lisa* remains a striking contradiction, which is perhaps the reason for its continued fame after all these centuries. The woman is smiling, but the rest of the picture speaks of desolation—the sun is absent, the landscape is dark and shrouded in mist, and Mona Lisa wears black clothes and a dark veil in her hair, a sign of mourning.

Perhaps the best perspective on the meaning behind the *Mona Lisa* was written by Bernard S. Myers in *Art and Civilization:*

> The half-smiling and reserved face of the *Mona Lisa* expresses . . . the detached, questioning, even cynical personality of Leonardo himself. It is surely like most of the women's faces in Leonardo's works . . . reflecting his own attitude . . . placed . . . against the

romantic landscape with its winding river and typical Leonardesque atmospheric haze.

Ideal estimates of this kind are characteristic of the . . . artist's own personality and philosophical approach. It would be a mistake, however, to assume that the [person] portrayed—or the artist for that matter—partook of the apparent serenity of the picture. The very opposite may be assumed in this case, for Leonardo was a disillusioned man in his fifties at that point, a perpetual wanderer who had been driven out of Milan by the French invasion to follow Cesare Borgia's armies in their ruthless attempt to achieve control for the Papal States in confused and unhappy early sixteenth

A musician and others keep Mona Lisa entertained while Leonardo works on her portrait. Vasari maintained that the model was Giocondo's wife, but others suggest that Leonardo used his own face as a model.

The *Mona Lisa* Is Stolen

After Leonardo died, the king of France, François I, paid four thousand gold ecus, or about $105,000, to add the Mona Lisa *to France's royal collection. By 1911, the painting was so valuable that it became a target for thieves. According to "Seeking Mona Lisa," an article by Joseph A. Harriss in the May 1999* Smithsonian:

"The biggest art heist in history occurred [in 1911] with Parisians waking up on August 23 to screaming headlines like the one in the daily *Excelsior:* 'The Louvre's [*Mona Lisa*] Stolen: When? How? Who?' The answers were a long time coming, as an army of French, German, Russian, Greek and Italian detectives went on a merry, futile chase for two years. Then . . . an Italian laborer named Vincenzo Perugia got tired of keeping the original in the false bottom of a trunk.

Perugia, who had worked in the museum, used his knowledge of it to lift the painting. He was put up to it by an Argentine con man named Eduardo de Valfierno, who had a skilled art forger knock off six copies. Valfierno then sold the copies to eager, if unscrupulous, collectors—five in North America, one in Brazil—who thought they were getting the real thing straight from the Louvre. The scam made him the equivalent today of $67 million. When Valfierno didn't claim the original—ironically, he didn't need it for the operation—Perugia naively offered it for sale to a Florence art dealer and was promptly pinched. The Mona Lisa returned to France on December 31, 1913. . . . Incredibly, the painting had suffered no physical damage."

Adding to the painting's mystique, some believe that the Mona Lisa *returned to the Louvre was one of the forgeries and that the real* Mona *is still hidden away somewhere.*

Vincenzo Perugia, an employee in the Louvre who stole the Mona Lisa *in 1911.*

century Italy. In view of these circumstances, the so-called serene portraits by Leonardo . . . may be regarded as attempts to detach [himself] from the times . . . rather than to reflect them directly.[68]

FIGHTING FAMILY BATTLES

While Leonardo was painting the *Mona Lisa* and the *Battle of Anghiari,* he was also waging legal battles with his half-brothers over their deceased father's estate. Strangely enough, Ser Piero, a notary, had died leaving no legal will. The children of his fourth marriage united against those of his third to obtain a large share of his estate. Then all combined to disinherit Leonardo, the notary's eldest son, who had been born out of wedlock. On April 30, 1506, a committee of lawyers reached a settlement from which Leonardo was excluded.

A few months later, Leonardo's uncle Francesco died without heirs. As if to correct the injustice done to Leonardo, Francesco left his entire estate to the artist, who was his favorite nephew. The estate had originally belonged to Leonardo's grandfather and held a special sentimental value to the artist. Again, Leonardo's half-brothers conspired against him to change the will.

Leonardo was outraged by his half-brothers' behavior and decided to fight them, calling on friends in high places to argue his case. At least two letters on his behalf were sent to the Palazzo della Signoria in Florence. One, dated July 26,

Louis XII (pictured) wrote a letter lending his support to Leonardo in the inheritance lawsuit against the artist's half-brothers.

1507, was from no less a person than France's King Louis XII:

> Very dear and great friends. We have been informed that our dear and well-beloved Leonardo da Vinci, our painter and engineer . . . has some dispute and litigation pending in Florence against his brothers over certain inheritances; and inasmuch as he could not devote himself properly to the pursuit of the said litigation by reason of his continual occupation in

our entourage and in our presence; and also because we are singularly desirous that the said litigation should be brought to an end in the best and briefest delivery of justice as possible: for this reason we willingly write to you on the matter. . . . [Y]ou will be giving us a very agreeable pleasure in doing so.[69]

Although the Florentines were not obliged to reply to an edict issued by the French king, they certainly respected his word. Nonetheless, several months passed in which Leonardo was said to be at his wits' end wondering how he could win the lawsuit. Obliged to stay in Florence to plead his case, the artist was forced to put aside his works in Milan for the French, who were becoming impatient with his long absence.

PERFORMING AUTOPSIES

In the winter of 1507, while waiting for his lawsuit to be settled, Leonardo recorded and conducted an autopsy on a man over one hundred years old who had died of natural causes. The painter had previously dissected birds, horses, cows, monkeys, and humans, but only with the intent of discovering the architecture and mechanisms of the body such as its appearance, movement, and function. This time Leonardo was attempting to find the cause of death.

Leonardo discovered upon examining the old man's vital organs that death had been due to the thickening of veins and arteries near the heart. He wrote in his

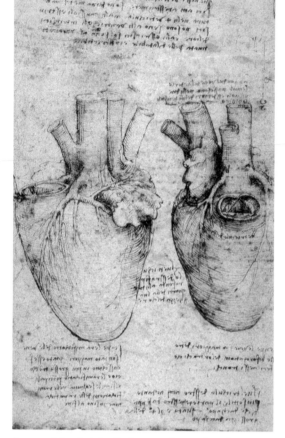

Leonardo's sketch of a human heart, based on an autopsy he performed.

notebook: "I carried out the autopsy . . . and discovered that [death] was the result of weakness produced by insufficiency of blood and of the artery supplying the heart and other lower members, which I found to be all withered, shrunken, and dessicated."[70]

With this discovery, Leonardo produced the first description in medical history of arteriosclerosis—hardening of the arteries. He also drew pictures of the twisted and contorted veins in his notebook. Then, for page after page, Leonardo

drew the muscles of the man's arm and shoulder, showing them at all angles, in three-dimensional scale, using different colored inks and washes. The artist went on for thirty pages drawing pictures of the intestines, the stomach, the liver, and the curvature of the spine.

OVER TWO HUNDRED DRAWINGS

Leonardo, of course, was not the first man to dissect the human body. He was, however, the first to draw it accurately, systematically, and in detail. The results of several autopsies performed by Leonardo were a series of over two hundred illustrations of the human body that were as admirable for their beauty as for their scientific value. No one had ever completed such a work, and Leonardo's drawings of human anatomy would not be rivaled until the eighteenth century.

This was grisly work, however. Leonardo wrote:

> I have dissected more than ten human bodies . . . removing the very minutest particles of the flesh by which these veins are surrounded. . . . And if you should have a love for such things you might be prevented by loathing, and . . . you might be deterred by the fear of living in the night hours in the company of those corpses . . . horrible to see.[71]

In spite of the unpleasantness of the work, Leonardo considered his anatomical work to be his major contribution to human knowledge, and during this period of his life he spent more time doing it than anything else. And this work did not come easy to him, as did painting. He worked long lonely nights in the morgue with a small collection of surgical instruments, tirelessly and without much assistance.

Leonardo wanted his anatomical drawings printed by means of engraved copper plates, but the research took so much of his time that he was never able to put

Leonardo produced over two hundred illustrations of the inner workings of the human body, including this one of the muscles in the shoulder.

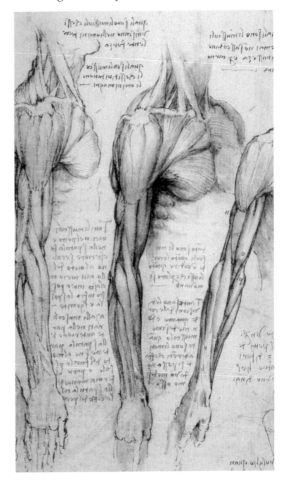

his drawings in a final order. They were, however, copied and circulated among medical students in Italy for decades. No one took the trouble to print them for more than two hundred years.

RETURN TO MILAN

At long last the verdict was rendered in one of Leonardo's lawsuits: Uncle Francesco's will was found to be valid and an acceptable settlement in Leonardo's favor was reached. The artist set off for Milan in the summer of 1508. His work in Florence was finished; Leonardo would return to the city five more times in the next several years, but only for short periods.

Leonardo set about renewing his contacts with Milanese authorities. He had written d'Amboise several times but, ominously, received no reply. Several drafts of a final letter survive. In one of these he wrote:

I am fearful lest the small return I have made for the great benefits I have received . . . have made you somewhat annoyed with me. And this is why, to many letters which I have written your Excellency I have never had an answer. . . . I should be very glad to know where, on my return from this place, I shall have to reside, because I do not wish to give more trouble to your Lordship; and then, having worked for the most Christian King, whether my salary is to be continued or not.[72]

The governor must have responded in a generous manner to Leonardo's letter because in July 1508, the painter was back in Milan and living in splendor. But life in the city was much different: Ludovico was dead, the *Last Supper* was peeling from the walls, litigation over *Virgin of the Rocks* continued, and the *Great Horse* was gone. But at the age of fifty-six, Leonardo was about to begin a new life in Milan with more money and prestige than he had ever had before.

Chapter

6 Uniting the Vision

In 1508, Leonardo returned to Milan, where he was a commissioned officer in the service of the French king Louis XII. This was not an honorary position, but one that meant Leonardo's advice could be called upon at any time, and that he would be part of the inner cabinet that ruled the city. For his position, Leonardo received a generous salary and could demand anything he wanted. To the French, Leonardo was a prize to be flaunted, and his very presence gave legitimacy to their rule in Italy.

Although his name was mentioned by the populace in reverent tones as if he were a sage, no one knew about the brilliant research that filled his notebooks. Instead his fame rested mostly on the *Last Supper* and the *Great Horse*, now destroyed. But these alone were considered immense accomplishments and were well remembered by anyone who ever saw them. People spoke of his technical skill, his artistic audacity, and the divine creative spark within him. The French treated him with utmost respect and reverence, even though the painter never bothered to learn their language.

A WIDE VARIETY OF WORK

At this time Leonardo was attempting to unite all his studies into a broad understanding of the human body and its place in the universe. According to the website maintained by the Institute and Museum of the History of Science in Florence, Italy,

> His penchant for theory intensified in his last years. He studied mechanics, anatomy, and geology in a closely interlinked manner, regarding them as governed by universal laws. He conceived the human body as a set of perfect mechanisms. Geometry was an abiding interest. Leonardo was particularly fascinated by the transformations of the surfaces of geometric shapes, which he applied to hydrology and to studies of the heart.[73]

These complex studies, however, did not prevent him from taking on commissions. When he was not decorating palaces, he was designing canals. He prepared pageants, planned monuments, studied outer space, and painted immortal pictures.

Geometry was yet another of the subjects Leonardo pursued in his quest for knowledge and understanding.

Around 1508, Marshal Gian Trivulzio, one of Louis XII's generals, asked Leonardo to design a monumental statue for his tomb, decorated with a life-size bronze horse and rider. Leonardo returned to his study of horses and their movements. The artist drew up intricate plans and a budget that estimated the cost of every aspect of building the great bronze statue. In page after page of his notebook he wrote the cost of every item and every process needed to construct the statue, ending with these items and the final cost in ducats (duc.):

And for squaring and carving the moulding of the pedestals at 2 duc. each, and there are 8 . . . duc. 16.

And for 6 square blocks with figures and trophies, at 25 duc. each . . . duc. 150.

And for carving the moulding of the stone under the figure of the deceased . . . duc. 40.

For the statue of the deceased, to do it well . . . duc. 100.

For 6 harpies with candelabra, at 25 ducats each . . . duc. 150.

For squaring the stone on which the statue lies, and carving the moulding . . . duc. 20.

in all . . . duc. 1075

The sum total of every thing added together amount to . . . duc. 3046.[74]

Political matters intervened once again, however, and the general lost interest in Leonardo's second attempt at a great horse.

Meanwhile, Charles d'Amboise encouraged Leonardo to design a *palais de luxe* (luxury palace) as a residence for the French governor. The artist used his talents to fill the proposed palace with all manner of luxuries. In the summer, the rooms of the palace would be cooled by water. Leonardo also devised a secret fountain in the garden to give a "shower bath" to those who passed through there. The garden itself was to be roofed with copper netting to prevent songbirds from escaping, and, as Leonardo wrote, "by means of a mill I will make un-

ending sounds from all kinds of instruments, which will make music as long as the mill continues to move."[75] In short, Leonardo had designed a small paradise for the French governor.

Meanwhile, in an attempt to make large sums of money, Leonardo considered manufacturing various chemical substances of his invention. These items included large artificial pearls made from mother-of-pearl dissolved in lemon juice and reformed; artificial amber made from black pudding skins boiled with egg white; and a primitive form of plastic made from eggs, glue, and vegetable dyes. The plastic substance—whose formula was left incomplete so as to remain a secret—could be scraped and shaped and used to form knife handles, chess pieces, pen holders, boxes, lamps, jewelry, and other items.

CONTINUED RESEARCH ON THE HUMAN BODY

Around 1510, Leonardo expanded his anatomical investigations to a study of biology in general, after a break of nearly a decade. During this round of dissections, Leonardo's studies in mechanics influenced his theories about the human body. He analyzed the joints in the elbows, knees, and elsewhere and determined they were governed by the laws of leverage.

Leonardo was also influenced by his studies of water and how it related to human biological function. In this work, which he had begun in Milan around 1490, he examined in detail the circulatory, respiratory, and urogenital systems, noting the similarity to networks of channels carrying fluids in motion. His notes, now collected in *Codex Leicester*, compare rain, which rises in clouds from the sea, to blood in the body:

> The waters return with constant motion from the lowest depths of the sea to the utmost height of the mountains, not obeying the nature of heavier bodies; and in this they resemble blood from animated beings [humans and animals] which always moves from the sea of the heart and flows towards the top of the head.[76]

Leonardo compared the motion of fluids in the body to networks of channels.

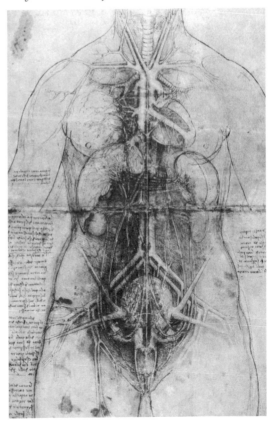

Leonardo also compared the passage of blood through the heart to water in a narrow channel, showing that the water carried by the streams brings nutrients to the earth's body, as blood does to the human body.

Leonardo spent hours dissecting human and animal eyes in an attempt to discover exactly how they functioned. He had used the information gleaned in these studies to write a book on the eye, now called *Manuscript D.* In it, he tried to summarize the workings of the eye from his years of notes on the subject. He showed the parts of the eye, and tried to trace the path of light through the eye. He found that light passed through the pupil and turned the image upside down. This principle was later used to invent the early photographic camera called the camera obscura.

While searching for the spark of energy that ignited life itself, Leonardo dissected a fetus that had been stillborn. The distinguished British art historian Lord Kenneth Clark writes:

A whole notebook dating from about 1512 is devoted to embryology, and he makes what must be one of the first drawings of a child in the womb. When we remember the tenderness and delicacy of feeling which all early authori-

THE SEARCH FOR THE SOUL

Leonardo's research went beyond the mechanics of the human body. He wanted to learn the secret that sparked human life, caused embryos to grow, and carried the body through the cycle of life from fetus to old age. To Leonardo these elements held the key to existence. In The Notebooks of Leonardo da Vinci, *the artist wrote about his search for the soul.*

"Though human ingenuity may make various inventions . . . it will never devise any inventions more beautiful, nor more simple, nor more to the purpose than Nature does; because in her inventions nothing is wanting, and nothing is superfluous . . . [S]he puts into them the soul of the body, which forms [in] the soul of the mother [who] first constructs in the womb the form of the man and in due time [nature] awakens the soul that is to inhabit [man]. . . .

The soul seems to reside in the judgment, and the judgment would seem to be seated in that part where all the senses meet; and this is called the Common Sense and is not all-pervading throughout the body as many have thought."

Leonardo, however, seemed overwhelmed by his research into the soul and wrote that he would leave the final answers to "friars, the fathers of the people, those who discover all secrets through divine inspiration."

ties attribute to Leonardo we can realise some of the noble and passionate curiosity which drove him to make such a terrible dissection, and to draw it with such a lucid and purposeful touch.[77]

Leonardo was almost overwhelmed by the awesome complexity of the human body. He became convinced that every structure of the human body had a precise function and that no detail must be overlooked in the visual representation. To solve these problems, Leonardo invented new graphic devices to portray the parts of the body, such as "see-through" images, exploded views, and the depiction of muscles as lines of force.

MANUSCRIPT F

The incredibly inventive mind of Leonardo seems never to have rested. In addition to all of his other work, he found time to begin work on what is called *Manuscript F*. The opening pages of the manuscript are dated September 28, 1508. On the inside of the gray cardboard cover, Leonardo makes a list of subjects to study and books to buy.

The artist reminds himself to "write a speech on the velocity of the heavens . . . study concave mirrors . . . [and] inflate the

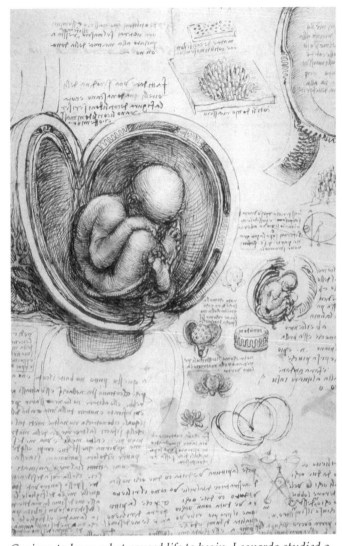

Curious to learn what caused life to begin, Leonardo studied a stillborn baby and produced this rendering of a fetus in the womb.

lungs of a pig and observe whether they increase in length and breadth or the breadth diminishes the length."[78] Leonardo also wanted to read the philosophy of Aristotle, obtain a book on Italian and Latin vocabulary, and study the works of Archimedes concerning the center of gravity.

The 192 pages of the book originally known as *Manuscript F* are largely concerned with the study of water. Leonardo had already written hundreds of pages on the subject, which fascinated him as he marveled at water's delicacy, its strength, and the nature of its properties. In *Manuscript F*, he decided to write fifteen chapters—a complete treatise on water. Leonardo listed the contents of each section, or book:

Book 1 of water in itself.

Book 2 of the sea.

Book 3 of subterranean rivers.

Book 4 of rivers.

Book 5 of the nature of the abyss.

Book 6 of the obstacles.

Book 7 of gravels.

Book 8 of the surface of water.

Book 9 of the things placed therein.

Book 10 of the repairing of rivers.

Book 11 of conduits.

Book 12 of canals.

Book 13 of machines turned by water.

Book 14 of raising water.

Book 15 of matters worn away by water.

Leonardo went on to list the sections of each book. In the book about rivers, for instance, he wrote, in part:

A book of driving back armies by the force of a flood made by releasing waters.

A book showing how the waters safely bring down timber cut in the mountains.

A book of boats driven against the impetus of rivers.

A book of raising large bridges higher.

Simply by the swelling of the waters.

A book of guarding against the impetus of rivers so that towns may not be damaged by them.[79]

Leonardo filled page after page with such exhaustive outlines, which he hoped would provide the impetus for him to gather together all he had written on the subject and put it in order with new material. *Manuscript F* was the tenth or eleventh comprehensive study Leonardo had undertaken, and like the rest, it would remain unfinished.

THE SECOND ST. ANNE

During this period of his life, Leonardo returned to the themes of two major works and painted them anew. The artist finally resolved the lawsuit with the Confraternity of the Immaculate Conception over the *Virgin of the Rocks* rejected by the monks in 1483. To settle the matter, Leonardo returned periodically to Florence with an apprentice

CODEX ON THE FLIGHT OF BIRDS

When Leonardo realized that the design flaw in his futuristic flying machines had been reliance on human muscle power alone, he returned to his study of birds in flight. He wrote a book about the subject, described on the website maintained by The Institute and Museum of the History of Science in Florence, Italy.

"The Codex on the Flight of Birds . . . marks the start of a second research phase [on flight]. . . . He observed that birds rely less on their wing beat than on exploiting air currents and wind. He therefore examined how birds, when struck by air currents, manage to keep their balance by moving their wings and tails. At the same time, he made an anatomical study of bird wings, demonstrating that the [under]wing acts as a brake. These investigations led Leonardo to substitute sail-flight [glider] projects for flapping-wing machines. Leonardo studied mechanical wings that could mimic the complex motions of bird wings.

Aerology and meteorology were an integral part of Leonardo's research on flight. He designed anemometers and hygroscopes to measure air resistance in flight. Leonardo compares air to water, and flight to swimming. As in swimming, a body that flies by flapping its wings moves forward by exerting a contrary thrust. In one of the flying machines, the pilot is housed in a boat-shaped hull. For Leonardo, the flying fish, which can both swim and fly, offers living proof of the analogy that links all living beings together."

A page from the Codex on the Flight of Birds.

to complete a second painting of the Virgin.

Meanwhile, Leonardo worked on a second painting of the *Virgin and Child with St. Anne,* this one probably commissioned by Louis XII. In this painting, Leonardo returned to the themes he had explored in his first painting of *St. Anne* in 1499, painting the heads of the grandmother, mother, child, and lamb to form a diagonal that unites them and brings together the composition of the picture. The rocky landscape seems farther away than ever, receding into the misty blue distance. The lamb, the traditional symbol of religious sacrifice of the innocent, is embraced by the young Jesus.

Leonardo's theme seems to be that the past and future happen at the same time: The mother and the grandmother both seem to be young, and it seems the mother foresees the sacrifice of the child, holding him back from his embrace of the lamb.

In *The Sublimations of Leonardo da Vinci,* Raymond Stites ties the painting to Leonardo's earlier studies of the fetus:

> The streams of water that flow through the background presumably end in the pool that is in the foreground. . . . Between the feet of the St. Anne in this pool is a distinctly recognizable embryo of two or three months, with a number of similar forms, each smaller than the last, which seem to be a row of tinier fetuses. . . . The embryos in the pool suggest primarily that he has pushed forward his research in embryology and has finished his work in that field.[80]

Leonardo's second version of the Virgin and Child with St. Anne. *Leonardo composed this painting so that the observer's eye follows the heads of St. Anne, Mary, Jesus, and the lamb in a diagonal line.*

LEDA AND THE SWAN

Another painting from this period is called *Leda and the Swan.* It is based on the legend in which the Greek god Zeus took the shape of a swan to seduce Leda, the

wife of the king of Sparta. In a plot that would have appealed to Leonardo's sometimes bizarre sense of humor, Leda gives birth to two eggs, containing two sets of twins.

Leda is the only female nude that is attributed to Leonardo, and also his only painting that was inspired overtly by a legend from antiquity. Leonardo's *Leda* was destroyed in about 1700, probably burned for its pagan images by the ministers of Louis XIII.

Some believe that Leonardo's later works, such as *Leda*, the *Mona Lisa*, and the *Virgin and Child*, unite the artist's vision to his scientific studies. Bramly writes:

> Each subject's smile seems to attempt to express the [inexpressible], as if Leonardo were putting into these paintings not only his science but his metaphysics—that which lies beyond the frontiers of the natural sciences.

His *Leda*, for instance, summarizes, continues, and in a sense completes his approach to "animal" reproduction and embryology[81]

TIME AND SPACE

Profoundly aware of the properties of light in painting, Leonardo conducted in-depth

Leda and the Swan *was inspired by a story from Greek mythology in which the god Zeus assumed the form of a swan to seduce Leda, a mortal woman.*

studies of light waves by observing the way sunlight was scattered by waves in the water. While studying light, Leonardo noticed how reflections from the light of the moon scattered in all directions, which suggested to him that there were waves of water on the moon, and wind to cause them. He concluded that the moon had its own atmosphere and gravity. Seeing the moon reflecting the rays of the sun, Leonardo thought the sun must

illuminate other heavenly bodies. He saw the earth as a speck in the universe, illuminated by the sun.

Unlike almost everyone else at that time, Leonardo did not believe that the earth was the center of the universe. Instead, he saw the sun as a great and powerful heavenly body at the center of the planets. (About thirty-five years later, the astronomer Copernicus published a treatise stating that the sun was the center of our universe. Modern astronomy is built on the foundation of the Copernican system.)

In *The Mind of Leonardo da Vinci*, Edward McCurdy elaborates:

Like da Vinci, Polish astronomer Copernicus (pictured) believed that the sun, not the earth, was the center of the solar system.

Before [astronomers] Copernicus or Galileo, before [philosopher Francis] Bacon [or Isaac] Newton . . . [Leonardo] uttered fundamental truths the discovery of which is associated with their names. "The sun does not move." "Without experience there can be no certainty." "A weight seeks to fall in the center of the earth by the most direct way." "The blood which returns when the heart opens again is not the same as that which closes the valve." This is not the language of the seer, but of the observer.[82]

Leonardo also made complex observations about the nature of time—hundreds of years before physicist Albert Einstein stated his theory of relativity in the early twentieth century.

POLITICAL CHANGES

As Leonardo approached his sixtieth year, political changes once again interrupted his life of peaceful painting and research. In 1511, Charles d'Amboise died of malaria, putting to an end Leonardo's plans for a *palais de luxe* with a magical garden and musical mill. The next year, his protector and patron, Louis XII, began to lose his hold on Milan as hostile powers began to conspire against the French king.

In June 1512, Spain, Venice, and Switzerland joined forces with Pope Julius II with the objective of reestablishing the Sforza dynasty in Milan. The

LEONARDO'S INVENTIONS

By the time Leonardo was sixty, he had filled dozens of notebooks with drawings and sketches of new inventions or improvements on existing ones. A few of the hundreds of machines that occupied the mind of Leonardo da Vinci are listed in alphabetical order.

Anemometer (instrument for measuring wind force and velocity)
Antifriction bearings
Articulated wing
Bridge-canal with sluice gates
Bronze-smelting kiln
Bicycle
Clock mechanism
Crank-operated cart
Crossbow machine
Diver's breathing apparatus
Emergency bridge
Flapping wing
Floats for walking on water
Flying machine
Grindstone with sieve
Hammer winch
Hand flipper
Helicopter
Hole-boring machine
Hygrometer (instrument that measures humidity)
Inclinometer (instrument that measures the slope of a hill or road)
Ladder
Lifebuoy
Light winch
Loom (automated)
Mirror-polishing machine
Multibarreled machine gun

Paddle boat
Parachute
Pole-erecting machine
Rack and pinion
Roller-bearing axle
Rolling-mill
Screw-press for oil
Speed gauge for wind or water
Spotlight
Spring-driven vehicle
Stabilizer
Steam cannon
Tank
Three-geared winch
Thread twister
Three-speed gear
Traction device
Ventilator
Wheeled gun
Worm-screw jack

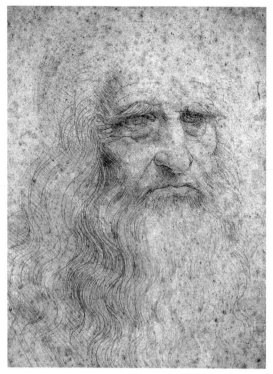

Leonardo's self-portrait, drawn when the artist was about sixty-one years old and living with his apprentice Melzi's family in Vaprio.

Maximilian Sforza, Ludovico's son, as ruler of Milan.

Maximilian, who knew that Leonardo had served his father, also knew of the artist's present connection to Louis XII. Unsurprisingly, Maximilian offered Leonardo no employment, and the painter was forced to move to the Melzi estate in Vaprio, where he spent most of 1513.

During this time, Leonardo wandered the hills, sketching the landscape. He offered the Melzis a host of plans for enlarging and improving their villa, and in the absence of human cadavers, he dissected animals. He brought these various works together in his manuscripts: On one sheet of paper dated January 9, 1513, the artist drew architectural plans for the Melzis next to studies of the digestive and respiratory organs.

Leonardo could not live with the Melzis indefinitely, and at the age of sixty-one, the great artist once again set out to find a new patron who could provide him with funds in his declining years. During this unhappy time, Leonardo used red chalk to draw his famous self-portrait, showing the frowning artist with long, gray hair and beard, and the sad eyes of a sorrowful sage.

French were taken by surprise at this new turn of events, and their military forces were not prepared to resist. Twenty thousand Swiss troops soon marched into Milan and installed young

7 Visions of the End

The year 1513 was an eventful year on the Italian political stage. Giovanni de' Medici, the younger son of Lorenzo de' Medici, Leonardo's first patron in Florence, had ascended to the papal throne, taking the name Leo X. Thus the Medici banking family acquired a connection by which to strengthen secular power over the Vatican and recover military power for Florence after nearly twenty years of disgrace.

Leo X was different from previous, more conservative popes. He loved food and, according to Bramley, "took pleasure in hunting, cards, dice, music, and the company of clowns, whom it was said, he asked to debate the immortality of the soul at the dinner table."[83] Leo X encouraged the arts, literature, and music, which attracted a throng of artists and intellectuals to the Vatican.

Will Durant writes about the elevation of arts in the Vatican at that time, and the less esteemed role of science:

> [T]hought was freer in Italy, and education more advanced, than in any other country in the fifteenth and early sixteenth centuries. . . . [P]atronage and honor went to art, scholarship, and poetry, and there was as yet

no clear call, in the economic or intellectual life of Italy, for scientific methods and ideas. A man like Leonardo could take a sweeping cosmic view, and touch a dozen sciences with eager curiosity; but there were no great laboratories, dissection was only beginning, no microscope could help

Pope Leo X was a patron of the arts, music, and literature.

biology or medicine, no telescope could yet enlarge the stars and bring the moon to the edge of the earth. The medieval love of beauty had matured into magnificent art; but there had been little medieval love of truth to grow into science.[84]

SETTLING IN ROME

Leonardo moved to Rome around October 1513 at the request of the pope's brother, Giuliano, commander in chief of the papal troops. The artist was given living quarters in the Belvedere, a luxurious villa inside the Vatican near the papal palace. A bill for repairs to the villa lists improvements made to the rooms, including enlargement of windows, decorations to bedrooms, and the purchase of furniture.

Leonardo was given a laboratory and a studio workshop with paid assistants, while the extensive Vatican library was at his disposal, allowing him to continue research on the dozens of subjects that interested him. Leonardo especially enjoyed the magnificent Vatican garden which held rare plants from all over the world. A zoo on the grounds of the Belvedere included a white elephant. The pope was said to dote on this rare specimen, and Leonardo, who had a high opinion of elephants, was said to prefer his unusual neighbor to the pope.

In the artistic and intellectual atmosphere that was Renaissance Rome, Leonardo met several old friends and acquaintances again, including the musician Atalante Migliorotti, and the painter Michelangelo, who had just finished painting the ceiling of the Vatican's Sistine Chapel.

FATHER OF A BYGONE AGE

Although the Vatican was now the thriving artistic center of Italy, many historians believe that this period was the most unhappy of Leonardo's life. Giuliano de' Medici was Leonardo's protector in Rome, but life was not easy. Pope Leo X mistrusted Leonardo, and Giuliano was often very ill and rarely saw the artist.

In addition, the old artist with the long white beard was no longer in fashion. Leonardo could only play the role of heroic father of a bygone age. Dozens of rivals around him—younger, faster, and more energetic—had numerous high-paying commissions. By contrast, Leonardo's modest stipend of thirty-three ducats a month was little comfort. In a city that had been described by Lorenzo the Magnificent as the "meeting place of all the vices"[85] the genius of Leonardo was overlooked in favor of con men and charlatans eager to siphon off some of the Vatican's generous patronage. Even worse, age had reduced the painter's competitive zeal and creative talents.

Leonardo might have also experienced health problems at this time, and must have been referring to personal experiences with medicine and doctors when he wrote:

To keep in health, this rule is wise. . . .
He who takes medicine is ill advised.

. . . I will teach you to preserve your health . . . you shun physicians, because their medicines are the work of alchemy, which has produced as many books as remedies.[86]

Leonardo's eyes were also failing him at this time. He had mentioned buying spectacles when he was in the service of Borgia, and now he made a note to buy blue eyeglasses, probably to protect his aging eyes against southern Italy's bright sunlight.

INTELLECTUALLY ACTIVE

In spite of his problems, Leonardo's mind remained as active as ever. He threw himself into the study of weight, air, motion, geometry, math, botany, and anatomy. He was particularly interested in the study of the lungs—he compared breathing to the ebb and flow of the ocean. (This research may have been part of an attempt to help Giuliano, who was dying of tuberculosis.) Leonardo also reflected on the mechanics of the voice and larynx, documenting the sounds made in the throat.

As in Milan, the artist continued to draw up new inventions, including an industrial rope-making device and a machine for minting coins. In addition to all of these studies, Leonardo focused pri-

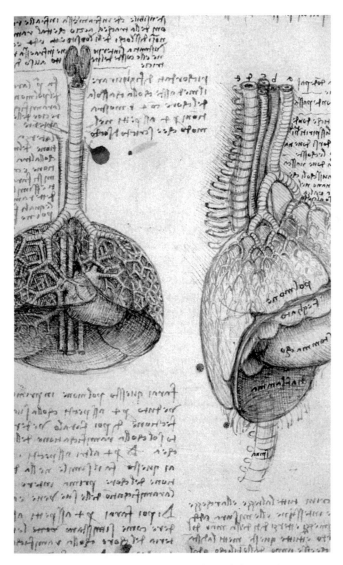

One of Leonardo's sketches of the respiratory system.

marily on mirror making, architecture, and hydraulics.

In 1514 Leonardo consulted with Pope Leo X on a scheme to drain the nearby Pontine marshes, which were commonly believed to breed disease. Leonardo had already pondered draining these marshes

LEONARDO THE ARCHITECT

Many new buildings were erected in northern Italy during Leonardo's life, but no cathedrals, palaces, or other buildings are known to be designed specifically by Leonardo. In spite of this, historians believe that Leonardo prepared plans for—and took an active part in—the construction of several public buildings. His name is definitely linked to the building of the cathedrals of Pavia and Milan.

Leonardo's architectural writings were dispersed among a large number of manuscripts, but there is little doubt that the artist had plans to write a complete treatise on architecture, which was never completed. In *The Notebooks of Leonardo da Vinci,* editor Jean Paul Richter has compiled Leonardo's notes into one extensive section that covers everything from the construction of church domes to the causes of cracks in the walls of existing buildings. For the latter, Leonardo writes: "Parallel fissures constantly occur in buildings which are erected on a hill side, when the hill is composed of stratified rocks."

Leonardo filled pages with drawings and analyses of arches and pillars. About arches he wrote: "The arch which throws its pressure perpendicularly on the abutments will fulfill its function." About pillars he wrote: "A pillar of which the thickness is increased will gain more than its due strength."

The one building that Leonardo was known to design was a stable to accommodate 128 horses in Milan. The building still stands today, and has been converted to a school called the Instituto Geografico Militare.

Leonardo's architectural drawings often included arches and pillars.

in 1503. With the help of Melzi, he drew up a map of the region along with plans to dig drainage canals to carry the water from the swamps to the sea. Digging began a few months later, but like many of Leonardo's other grand projects, the work was soon stopped and the Pontine marshes remained in their natural state until the end of the nineteenth century, when Leonardo's plan was finally implemented with few changes.

JOKES, POPES, AND PATRONS

Although Leonardo was busy with his work, he did not give up his role as a joker and a jester. On one occasion, he decorated a large living lizard like a dragon, with silver wings, a horn, and a beard. Another time, he used a blacksmith's bellows to inflate the dried intestines of a ram into a large balloon that filled a room. Vasari described the details of these strange jokes:

> On a curious lizard . . . [Leonardo] fastened scales taken from other lizards, dipped in quicksilver, which trembled as it moved, and after giving it eyes, a horn and a beard, he tamed it and kept it in a box. All the friends to whom he showed it ran away terrified. He would often dry and purge the guts of a [ram] and make them so small that they might be held in the palm of the hand. In another room he kept a pair of smith's bellows, and with these he would blow out one of the guts until it filled

the room, which was a large one, forcing anyone there to take refuge in a corner. The fact that it had occupied such a little space at first only added to the wonder. He perpetrated many such follies.[87]

Some have speculated that Leonardo perfected such stunts to win favor from the pope, who enjoyed unusual practical jokes. This plan must have worked, because Leonardo eventually was given a commission for a painting from Leo X. When Leonardo began the painting by first distilling the oils and the plants for the final varnish, the pope complained, "The man will never do anything, for he begins to think of the end before the beginning!"[88]

MIRRORS AND SPIES

Leonardo pursued other projects to win the favor of Leo X. The fortunes of the Medicis depended heavily on the textile industry. In light of this, Leonardo proposed to his patron a unique method of boiling vats of dye using bowl-shaped, or parabolic, mirrors to harness solar energy.

Since 1490, Leonardo had been contemplating using parabolic mirrors for welding operations. In his designs for the pope, however, Leonardo had another motive—he wanted to build an enormous reflector that would allow him to study the stars and planets.

To help him build his mirrors, Leonardo was given two German assistants, one a smith the other a mirror

maker. The men were called Master Giorgio and Master Giovanni of the Mirrors. Before long Leonardo was bitterly complaining about the men, whom he said "strongly criticized" him, refused to learn Italian, and were lazy and insulting. The Germans took special pleasure in hunting wild birds within the Roman ruins, a practice that especially irritated the bird-loving Leonardo.

Worse, Leonardo complained in a letter to Giuliano, the Germans were trying to steal the secrets to his inventions: "Giovanni, the German who makes the mirrors, was there always in the workshop, and wanted to see and to know all that was being done there and made it known outside."[89] Leonardo also wrote that one of the German "deceivers" wanted to make a model of the mirror out of wood, and "wished to carry it away with him to his own country"[90] where presumably he would attempt to make a prototype from Leonardo's design.

To thwart the spying, Leonardo began to write his metal formulas in secret code and his usual method of backward writing. Following the traditions of alchemy, Leonardo used the names of planets to refer to metals used to coat the mirrors: Venus for copper, Jupiter for tin, Saturn for lead, and Neptune for bronze.

HUMOROUS WRITINGS

Throughout his life Leonardo was famous for reciting humorous stories and jokes to friends, princes, and patrons. He also filled his notebooks with fables and morality stories. In The Notebooks of Leonardo da Vinci, *under the heading of "Jest," the artist tells an irreverent story about a painter and a priest, which sounds as if it might contain an element of truth.*

"A priest, making the rounds of his parish on Easter Eve, and sprinkling holy water in the houses as is customary, came to a painter's room, where he sprinkled the water on some of his pictures. The painter turned round, somewhat angered, and asked him why this sprinkling had been bestowed on his pictures; then said the priest, that it was the custom and his duty to do so, and that he was doing good; and that he who did good might look for good in return . . . since God had promised that every good deed that was done on earth should be rewarded a hundred-fold from above. Then the painter, waiting till [the priest] went out, went to an upper window and flung a large pail of water on the priest's back, saying: 'Here is the reward a hundred-fold from above, which you said would come from the good you had done me with your holy water, by which you have damaged my pictures.'"

Giovanni retaliated by trying to discredit Leonardo in the Vatican. The German reported to the pope that the artist had been practicing necromancy—attempting to communicate with the spirits of the dead in order to predict the future. When Leo X heard this, he forbade Leonardo to perform any more anatomical dissections at San Spirito hospital. Leonardo wrote: "[Giovanni] hindered me in anatomy, blaming it before the Pope; and likewise at the hospital."[91]

With so many people working against its success, Leonardo's great solar reflector was never built.

THE DELUGE AT THE END OF THE WORLD

By 1515, Leonardo's life took another somber turn. The pope's brother Giuliano—Leonardo's only patron—was near death. The artist had few friends and protectors in the Vatican, and his enemies did not hesitate to take advantage of the situation. He was banned from the dissecting rooms at the hospital, his health and physical appearance were diminishing, and he only had the young Melzi as an ally. Looking back on his life, he might have been saddened by the unfinished projects and hours wasted on seemingly dead-end theories. In his notebook he wrote:

O Time! consumer of all things; O envious age! thou dost destroy all things and devour all things with the relentless teeth of years, little by little in a slow death. . . . O Time! consumer

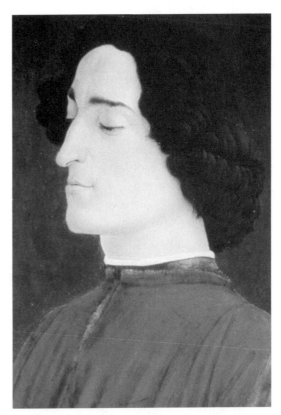

Giuliano de' Medici (pictured), commander in chief of the papal troops and Leonardo's patron in Rome, was ill with tuberculosis and rarely saw the artist.

of all things, and O envious age! by which all things are all devoured.[92]

With these troublesome thoughts on his mind, Leonardo began to write down descriptions of nightmarish events, including earthquakes, volcanic eruptions, and floods. In one scenario, the artist conceived of a surreal rain of objects falling from a dense cloud in the sky, including rakes, caldrons, compasses, lanterns, and whips.

As the end of his life drew near, Leonardo was moved to describe the end of the world in writing and to make plans

for a monumental fresco. As with earlier paintings, Leonardo wrote down what the mural would contain. As Bramly observes, the artist's words could be used to describe a brilliant twentieth-century movie: "it has a strong dramatic line, with cuts from one scene to another and exemplary camera movements."[93] Leonardo wrote long, extensively detailed notes on the subject, and he must have spent many dark days dreaming up the horrible scenario.

The text is called "Of the Flood and its representation in painting":

> Let the dark, gloomy air be seen beaten by the rush of opposing winds wreathed in perpetual rain mingled with hail, and bearing hither and thither a vast network of the torn branches of trees mixed together with an infinite number of leaves. . . . There might be seen huddled together on the . . . mountains many different sorts of animals, terrified and subdued at last to a state of tameness, in company with men and women who had fled there with their children . . . uttering various cries and lamentations, dismayed by the fury of the winds which were causing the waters to roll over and over . . . bearing with them the bodies of the drowned; and . . . various different animals . . . [standing] together in terror, among them being wolves, snakes, and creatures of every kind, fugitives from death. . . . And all the waves that beat against their sides were striking them with repeated blows from the various bodies of the drowned, and the blows were killing those in whom life remained. . . . Ah, what dreadful tumults one heard resounding through the gloomy air, smitten by the fury of the thunder and the lightning. . . . Ah me, how many lamentations! How many [people] in their terror flung themselves down from the rocks! . . . Alas! how many mothers were bewailing their drowned sons . . . declaiming their anger of the gods![94]

Leonardo sketched a dozen extraordinary drawings to accompany his description of the deluge. They show trees, horses, and people carried away on the winds; walls of water bursting into valleys; and entire towns with huge buildings tossed about in the water like toys.

LEONARDO'S LAST PAINTING

At the same time Leonardo was envisioning the horrors of the apocalypse, he was completing a painting that was totally opposite in feel and character. The dark and mystical work called *St. John the Baptist* shows the figure of the saint emerging from a dramatically smoky atmosphere.

Although John the Baptist is traditionally shown as a fiery preacher in the desert, announcing the coming of a Messiah, Leonardo shows him as soft and smooth, making personal silent contact with the viewer. He emerges gently and elegantly from the darkness, and his right hand points to heaven as he gestures to-

ward himself with his left hand. The only traditional symbol in the painting is the reed cross in his hand. Viewers at the time would have spotted the reference to Jesus' description of John the Baptist from Matthew 11:7 as "a reed shaken in the wind."

Rachel Annand Taylor comments on Leonardo's unusual depiction of a traditional subject: "The invitation of Saint John is . . . some mystery of beauty we do not altogether understand. For all [Leonardo's] inquiries and all his manuscripts he left his last secret unexplored and untold. He was in exile after all, and mortality lay on him in the form of fear."[95] Taylor suggests further that the realist and the idealist in Leonardo were increasingly at odds in the artist's old age.

Today, *St. John* hangs in the Louvre, near the *Mona Lisa*, both of their mysterious smiles inspiring viewers almost five centuries after their creation.

The smooth, gentle form and mysterious smile of his subject make Leonardo's version of St. John the Baptist *unique.*

LAST YEARS IN FRANCE

In January 1515, Louis XII, king of France, died. His nineteen-year-old cousin François I acceded to the throne, and almost immediately the French army crossed over the Alps into Italy. In July the king's artillery massacred the troops of Maximilian Sforza, and once again the French entered Milan in triumph.

The young François was an unusual ruler who bewitched all who met him. It was said that affairs of state never occupied him past noon, and he delighted in poetry, dancing, literature, and the company of women. During his midday meal, the king had classical authors read aloud to him.

Pope Leo X had made the mistake of sending his troops into battle against the

François I, king of France from 1515 to 1547, was an enthusiastic fan of Leonardo's and became the artist's last patron.

The artist finally settled in the Loire Valley, where François had recently returned.

François was deeply impressed by the artist, whom he referred to as his favorite painter, engineer, and architect. François took great pleasure in hearing Leonardo speak and considered him a great philosopher and the most cultivated man alive. The king granted Leonardo an exceptionally large pension and lodged him in a manor house that connected to the royal palace by means of a tunnel.

Leonardo's new house was surrounded by two and a half acres of gardens and contained a studio, bedrooms, a chapel, and more. A local woman took care of Leonardo's cooking and cleaning, and "Leonardo could not have hoped for a more comfortable or independent retreat."[96]

By this time, the sixty-five-year-old artist could not paint, for he was paralyzed in his right arm, possibly by a stroke. He continued to instruct Melzi, however, and so was able to continue the creative process on canvas. The view from Leonardo's window drawn by Melzi in the sixteenth century remains the same today.

Although Leonardo could no longer paint, he remained useful to the king. The great artist helped François plan a visionary château with a star-shaped network of waterways, fountains, a lake for aquatic spectacles, and a palace that would have rivaled Louis XIV's residence at Versailles, built more than one hundred years later. As with other projects, work began on the palace but was abandoned after a few years.

Leonardo also took charge of court entertainments, overseeing royal balls, cele-

remarkable French king. After losing, the pope attended peace talks in Bologna in October 1515. There, Leonardo was introduced to François, who would be his final benefactor.

Leonardo remained loyal to Giuliano Medici until his patron's death on March 17, 1516. It was then that Leonardo set out on a three-month journey with Melzi, visiting Florence, Milan, and the French cities of Grenoble, Lyon, and Amboise.

brations, baptisms, and marriages. As the end of his life drew near, the artist, assisted by Melzi, attempted to put his manuscripts in order. Leonardo's last entry in his notebook was on June 24, 1518. It stated simply "I shall continue."[97]

THE DEATH OF THE RENAISSANCE MAN

On April 23, 1519, a few days after his sixty-seventh birthday, Leonardo asked a notary to write out his last will and testament. And it appears that as his health was failing, Leonardo turned to religion. According to Vasari:

> At length, having become old, he lay sick for many months, and seeing himself near death, he desired to occupy himself with the truths of the Catholic Faith and the holy Christian religion. Then, having confessed and shown his penitence with much lamentation, he devoutly took the

King François holds the dying Leonardo in his arms. The "Renaissance man" died on May 2, 1519, at the age of sixty-seven.

Sacrament out of his bed, supported by his friends and servants, as he could not stand. The king arriving, for he would often pay him friendly visits, he sat up in bed from respect, and related the circumstances of his sickness.

Vasari goes on to describe how, on May 2, 1519, Leonardo died in the arms of the French king:

> He was then seized with a paroxysm, the harbinger of death, so that the king rose and took his head to assist him and show him favour as well as to alleviate the pain. Lionardo's divine spirit, then recognising that he could not enjoy a greater honour, expired in the king's arms. . . . The loss of Lionardo caused exceptional grief to those who had known him, because there never was a man who did so much honour to painting. By the splendour of his magnificent mien he comforted every sad soul. . . . His liberality warmed the hearts of all his friends, both rich and poor, if they possessed talent and ability. His presence adorned and honoured the most wretched and bare apartment. Thus Florence received a great gift in the birth of Lionardo, and its loss in his death was immeasurable.[98]

On June 1, Francesco Melzi wrote to one of Leonardo's half-brothers and told him of the artist's death. Melzi wrote that Leonardo was like a father to him and "it is impossible . . . to express the anguish his death had caused me."[99]

The burial of Leonardo was long delayed, most likely because various parties wanted to claim the body. There was a question of whether the remains should be returned to Italy or be buried in France, where the painter had lived out his final years.

Months later a burial took place in France, but the formal services were not well attended. Only a few servants and people from the local village paid their last respects when Leonardo da Vinci's body was laid to rest at the church of Saint-Florentin in Amboise, France, on August 12, 1519.

The great artist's body lay in peace for over two hundred years, but during the French Revolution the church where Leonardo was buried was destroyed. The coffins were melted down for their lead content and the remains of the dead were scattered. Children played games with the bones abandoned in the rubble until a gardener, upset by the sight, buried the remains in a common grave in the corner of the courtyard.

In 1863, a French poet excavated the site and found some bones and a skull believed to be Leonardo's. The remains were collected, then lost. Like the enigmas surrounding Leonardo's masterpieces and scattered notes, the whereabouts of the artist's bones remain a mystery.

LEONARDO'S LEGACY

After Melzi died in 1570, Leonardo's manuscripts were scattered throughout Europe. As the centuries passed, the artist's

LEONARDO'S MANUSCRIPTS

When Leonardo died he left his manuscripts to his devoted pupil Francesco Melzi, who brought them home to Italy. It was here that the public at large was able to see them for the first time.

Some scholars took pages of Leonardo's manuscripts away with them, but Melzi lovingly preserved most of the work. At one time he pieced together all of Leonardo's passages about painting, which in 1651 were published under the title *The Treatise on Painting*. This was the only book published under Leonardo's name until modern times.

When Melzi died in 1570, his son neglected the manuscripts, throwing them haphazardly in the attic. A tutor in the house later discovered the books and took thirteen of them to sell to the duke of Florence.

In the late 1500s, a sculptor named Pompeo Leoni began to collect as many of the notes as he could find. Leoni bound these together into several large volumes. One, containing the anatomical drawings, still exists today at Windsor Castle, home of the queen of England. The other codex, called *Codex Atlanticus*, is in the Ambrosiana Museum in Milan. The *Codex Arundel* is in the British Museum, and the *Madrid Codices I* and *II* were discovered in Spain in 1967.

Today, *Codex Atlanticus* and several other compilations of Leonardo's writings and drawings may be found published in books and posted on Internet websites.

In spite of the wealth of materials contained in Leonardo's writings, only about seven thousand pages of the thirteen thousand or so pages actually written by the master have been found.

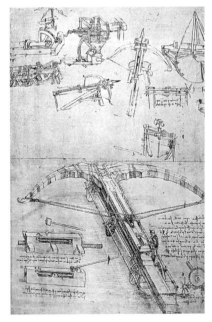

The plan of a giant crossbow from the Codex Atlanticus, *one of the compilations of Leonardo's writings and drawings.*

writings and drawings were acquired by lords, kings, and dictators. When Napoleon conquered Milan in 1796, Leonardo's codices were among the spoils of victory. The *Codex Atlanticus* was sent to the French national library, while the notebooks, designated by initials A, B, E, F, G, and so on, remained in the Institut de France in Paris. With the fall of Napoleon several years later, *Atlanticus* was returned to Milan, but the notebooks lay untouched and remain in Paris to this day.

Around 1815, people began to take interest in Leonardo's writings as well as his drawings, and the long task of translating them was undertaken by a French scholar. The translations became very popular, and three centuries after Leonardo's death, a new image of the man was created. Leonardo was finally recognized for his talents as a musician, architect, biologist, engineer, philosopher, and scholar.

The Leonardo who was rediscovered in the nineteenth century was a pioneer in art and science. He painted some of the greatest paintings the world has ever seen while inventing machines to relieve people from strenuous labor, planning cities and canals, and filling notebook after notebook with his discoveries. He explored the workings of the human body and the earth's machinery and came to understand them as no one had before. In this respect, Leonardo was the father of the modern age of science.

With a gentle and expert eye, Leonardo the painter created a lucid vision that allowed the rest of humanity to see through veils of nature and become aware of the perfection beyond the reach of the average eye. The painter Rubens said that Leonardo gave every object he painted "its most appropriate and most living aspect, and exalted majesty to the point where it becomes divine."[100]

Leonardo's secret writings remained unpublished for three hundred years, but time, neglect, wars, and the deeds of petty tyrants could not destroy the genius of Leonardo da Vinci.

Notes

Introduction: Artist, Inventor, Legend

1. Robert Payne, *Leonardo*. New York: Doubleday, 1978, p. xv.

2. Quoted in Joseph A. Harriss, "Seeking Mona Lisa," *Smithsonian*, May 1999, p. 56.

3. Ladislao Reti, ed., *The Unknown Leonardo*. Maidenhead, England: McGraw-Hill, 1974, p. 11.

4. Reti, *The Unknown Leonardo*, p. 11.

5. Reti, *The Unknown Leonardo*, p. 11.

Chapter 1: The Young Artist

6. Payne, *Leonardo*, p. 4.

7. Payne, *Leonardo*, p. 5.

8. Serge Bramly, *Leonardo: Discovering the Life of Leonardo da Vinci*, trans. Siân Reynolds. New York: HarperCollins, 1991, p. 41.

9. Bramly, *Leonardo*, p. 45.

10. Richard W. Hibler, *Life and Learning in Ancient Athens*. New York: University Press of America, 1988, pp. 62–63.

11. Leonardo da Vinci, *The Notebooks of Leonardo da Vinci*, vol. 1, ed. Jean Paul Richter. New York: Dover Publications, 1970, pp. 247–48.

12. Walter Pater, *The Renaissance*. New York: Macmillan, 1899, p. 104.

13. Giorgio Vasari, *Lives of Painters, Sculptors and Architects*. London: J. M. Dent & Sons, 1963, p. 156.

14. Ludwig H. Heydenreich, *Leonardo da Vinci*, vol 1. New York: Macmillan, 1928, pp. 20–21.

15. Vasari, *Lives of Painters, Sculptors and Architects*, p. 160.

Chapter 2: The Artist in Florence

16. Ivor Hart, *The World of Leonardo da Vinci: Man of Science, Engineer, and Dreamer of Flight*. Fairfield, NJ: Augustus M. Kelley, 1977, p. 77.

17. Rachel Annand Taylor, *Leonardo the Florentine*. New York: Harper & Brothers, 1928, pp. 4–5.

18. Heydenreich, *Leonardo da Vinci*, vol. 1, pp. 26–27.

19. Heydenreich, *Leonardo da Vinci*, vol. 1, p. 25.

20. Frederick Hartt, *History of Italian Renaissance Art*. New York: Harry N. Abrams, 1969, p. 444.

21. Ariane Ruskin, *Art of the High Renaissance*. New York: McGraw-Hill, 1968, p. 11.

22. Payne, *Leonardo*, p. 31.

23. Bernard Berenson, *Italian Painters of the Renaissance*. London: Phaidon Press, 1954, p. 180.

24. Bramly, *Leonardo*, pp. 112–13.

25. Quoted in Leonardo da Vinci, *Paragone*, ed. and trans. Irma A. Richter. London: Oxford University Press, 1949, p. 38.

26. Bramly, *Leonardo*, p. 113.

27. Bramly, *Leonardo*, pp. 139–40.

28. Will Durant, *The Renaissance: A History of Civilization in Italy from 1304–1576 A.D.* New York: Simon and Schuster, 1953, p. 209.

29. Charles Gibbs-Smith and Gareth Rees, *The Inventions of Leonardo da Vinci*. New York: Charles Scribner's Sons, 1978, p. 30.

30. Payne, *Leonardo*, pp. 60–61.

31. Gibbs-Smith and Rees, *The Inventions of Leonardo da Vinci*, p. viii.

Chapter 3: Art and Science in Milan

32. Vasari, *Lives of Painters, Sculptors and Architects*, p. 160.

33. Bramly, *Leonardo*, p. 181.

34. Bramly, *Leonardo*, p. 182.

35. Hart, *The World of Leonardo da Vinci*, p. 86.

36. Bramly, *Leonardo*, p. 179.

37. Vasari, *Lives of Painters, Sculptors and Architects*, pp. 160–61.

38. Hart, *The World of Leonardo da Vinci*, p. 88.

39. Durant, *The Renaissance*, p. 187.

40. Quoted in Emanuel Winernitz, *Leonardo da Vinci as a Musician.* New Haven: Yale University Press, 1982, p. 75.

41. Leonardo, *Paragone*, p. 8.

42. Quoted in Raymond S. Stites, *The Sublimations of Leonardo da Vinci.* Washington, DC: Smithsonian Institution Press, 1970, p. 125.

43. Leonardo, *Paragone*, p. 85.

44. Quoted in Richard Friedenthal, *Leonardo da Vinci: A Pictorial Biography,* trans. Margaret Shenfield. New York: Viking Press, 1959, p. 49.

45. Leonardo, *Paragone*, p. 39.

46. Ruskin, *Art of the High Renaissance*, p. 16.

47. Bernard S. Myers, *Art and Civilization.* New York: McGraw-Hill, 1957, pp. 401–402.

48. Friedenthal, *Leonardo da Vinci*, p. 74.

Chapter 4: The European Master

49. Payne, *Leonardo*, pp. 131–32.

50. Leonardo da Vinci, *The Notebooks of Leonardo da Vinci*, vol. 2, ed. Jean Paul Richter. New York: Dover Publications, 1970, p. 400.

51. Quoted in Hart, *The World of Leonardo da Vinci*, p. 317.

52. Leonardo, *The Notebooks of Leonardo da Vinci,* vol. 2, p. 278.

53. Bramly, *Leonardo*, pp. 287–88.

54. Vasari, *Lives of Painters, Sculptors and Architects*, p. 164.

55. Bramly, *Leonardo*, p. 323.

56. Gibbs-Smith and Rees, *The Inventions of Leonardo da Vinci*, p. 47.

57. Quoted in Durant, *The Renaissance*, pp. 209–10.

58. Stites, *The Sublimations of Leonardo da Vinci*, pp. 313–14.

59. Durant, *The Renaissance*, p. 210.

Chapter 5: Artistic and Personal Battles

60. Durant, *The Renaissance*, p. 210.

61. Vasari, *Lives of Painters, Sculptors and Architects*, p. 167.

62. Quoted in Bramly, *Leonardo*, p. 342.

63. Quoted in Payne, *Leonardo,* p. 220.

64. Vasari, *Lives of Painters, Sculptors and Architects*, p. 166.

65. Mary Rose Storey, *Mona Lisas.* New York: Harry N. Abrams, 1980, p. 14.

66. Vasari, *Lives of Painters, Sculptors and Architects*, p. 164.

67. Storey, *Mona Lisas*, pp. 13–14.

68. Myers, *Art and Civilization*, p. 403.

69. Quoted in Payne, *Leonardo*, pp. 224–25.

70. Quoted in Bramly, *Leonardo*, p. 372.

71. Leonardo, *The Notebooks of Leonardo da Vinci*, vol. 2, pp. 107–108.

72. Leonardo, *The Notebooks of Leonardo da Vinci*, vol. 2, pp. 405–406.

Chapter 6: Uniting the Vision

73. The Institute and Museum of the History of Science in Florence, Italy, "Leonardo the Engineer, (Vinci, 1452–Amboise, 1519)." http://galileo.imss.firenze.it/news/mostra/6/e61.html.

74. Leonardo, *The Notebooks of Leonardo da Vinci*, vol. 2, p. 17.

75. Quoted in Payne, *Leonardo*, p. 242.

76. Leonardo, *The Notebooks of Leonardo da Vinci*, vol. 2, p. 132.

77. Kenneth Clark, *Civilisation: A Personal*

View. New York: Harper & Row, 1969, p. 160.

78. Quoted in Payne, *Leonardo*, p. 240.

79. Leonardo, *The Notebooks of Leonardo da Vinci*, vol. 2, p. 176.

80. Stites, *The Sublimations of Leonardo da Vinci*, pp. 307–308.

81. Bramly, *Leonardo*, p. 376.

82. Edward McCurdy, *The Mind of Leonardo da Vinci*. New York: Dodd, Mead, 1948, p. 199.

Chapter 7: Visions of the End

83. Bramly, *Leonardo*, p. 382.

84. Durant, *The Renaissance*, p. 529.

85. Quoted in Bramly, *Leonardo*, p. 374.

86. Leonardo, *The Notebooks of Leonardo da Vinci*, vol. 2, p. 133.

87. Vasari, *Lives of Painters, Sculptors and Architects*, p. 166.

88. Quoted in Vasari, *Lives of Painters, Sculptors and Architects*, p. 166.

89. Leonardo, *The Notebooks of Leonardo da Vinci*, vol. 2, p. 408.

90. Leonardo, *The Notebooks of Leonardo da Vinci*, vol. 2, p. 410.

91. Leonardo, *The Notebooks of Leonardo da Vinci*, vol. 2, p. 410.

92. Leonardo, *The Notebooks of Leonardo da Vinci*, vol. 2, pp. 291–92.

93. Bramly, *Leonardo*, p. 390.

94. Quoted in Heydenreich, *Leonardo da Vinci*, vol. 1, pp. 156–57.

95. Taylor, *Leonardo the Florentine*, p. xxiii.

96. Bramly, *Leonardo*, p. 399.

97. Quoted in Bramly, *Leonardo*, p. 401.

98. Vasari, *Lives of Painters, Sculptors and Architects*, p. 167.

99. Quoted in Payne, *Leonardo*, p. 292.

100. Quoted in Payne, *Leonardo*, p. 307.

For Further Reading

Charles Gibbs-Smith and Gareth Rees, *The Inventions of Leonardo da Vinci*. New York: Charles Scribner's Sons, 1978. Gibbs-Smith was the Lindbergh Professor of Aerospace History at the National Air and Space Museum, and Rees was associated with the Leicester Polytechnic in England. Together they compiled a book that focuses on the tanks, flying machines, water turbines, gearboxes, and other mechanical inventions of Leonardo.

Joseph A. Harriss, "Seeking Mona Lisa," *Smithsonian*, May 1999. A lighthearted article about the *Mona Lisa* detailing the history of the painting, its value as a modern icon, and various humorous explorations into its meaning.

International Business Machines, *Leonardo da Vinci*. New York: IBM Department of Arts and Sciences, n.d. IBM constructed actual physical models from Leonardo's drawings of futuristic inventions. This fascinating book contains photos of the working models and explanations for the logic behind Leonardo's parachutes, helicopters, tanks, odometers, and other inventions.

Kenneth Keele, *Leonardo da Vinci and the Art of Science*. Sussex, England: Wayland, 1977. A book for young adults that focuses on the scientific aspects of Leonardo's career as an engineer, designer, and city planner.

Emery Kelen, ed., *Fantastic Tales, Strange Animals, Riddles, Jests, and Prophecies of Leonardo da Vinci*. New York: Thomas Nelson, 1971. The title explains the content of this amusing and amazing book of tales, illustrated with drawings by Leonardo himself.

Leonardo da Vinci, *Leonardo Knows Baseball*. San Francisco: Chronicle Books, 1991. In all likelihood, Leonardo did not foresee the sport of baseball, but this book uses the artist's words about the mechanics of the human figure to explain monographs by artist Charles Hobson, which depict baseball players in motion.

———, *The Notebooks of Leonardo da Vinci*. Ed. Jean Paul Richter. 2 vols. New York: Dover Publications, 1970. A great majority of all the surviving words that Leonardo wrote are contained in these two books. Although the artist's writing style does not often make for easy reading, these books give great insight to Leonardo's character and are illustrated with more than seven hundred of his sketches, drawings, and paintings. Any fan of the artist should examine these books.

Richard McLanathan, *Leonardo da Vinci*. New York: Harry N. Abrams, 1990. A young adult biography of Leonardo written by a consultant to the National Gallery of Art in Washington, D.C.

Ernest Raboff, *Leonardo da Vinci*. New York: Harper & Row, 1987. Part of Raboff's Art for Children series, this book imaginatively presents the paintings of Leonardo. It contains helpful interpretations of the works and beautiful full-color reproductions.

Mary Rose Storey, *Mona Lisas*. New York: Harry N. Abrahms, 1980. This book gives a brief description of the history of the most famous painting in the world, and fills the rest of the pages with dozens of renditions and spoofs of the painting. It includes Andy Warhol's silk-screens, Marcel Duchamp's *Mona Lisa* with a mustache, *Mona Lisa* on a one-dollar bill, *Mona Lisa* with the face of Jackie Kennedy Onassis, *Mona Lisa* with the head of a gorilla, *Mona Lisa* cross-eyed, with her hair in curlers, and more.

Emanuel Winernitz, *Leonardo da Vinci as a Musician*. New Haven: Yale University Press, 1982. This book focuses on Leonardo's talent as a gifted musician and is one of the only works to detail Leonardo's contributions to music. Also covered is the artist's career as a theatrical designer as well as his composition of musical riddles and humorous songs. Valuable for anyone interested in the study and playing of music.

Works Consulted

Serge Bramly, *Leonardo: Discovering the Life of Leonardo da Vinci.* Trans. Siân Reynolds. New York: HarperCollins, 1991. Bramly ties together ancient legal documents, Leonardo's writings, and centuries of speculation and rumor to present one of the most complete modern biographies of Leonardo.

Bernard Berenson, *Italian Painters of the Renaissance.* London: Phaidon Press, 1954. An in-depth study of Renaissance painters, containing breathtaking color reproductions by artists from Venice, Florence, central Italy, northern Italy, and so on, including the work of Leonardo.

Kenneth Clark, *Civilisation: A Personal View.* New York: Harper & Row, 1969. A book made up of television scripts used in a series of British educational programs illuminating the history of Europe. The book utilizes art and architecture to show the evolution of civilization throughout the centuries.

Will Durant, *The Renaissance: A History of Civilization in Italy from 1304–1576 A.D.* New York: Simon and Schuster, 1953. The author, born in 1885, is one of the most famous historians of his day, having written ten volumes on the history of civilization; this book is Volume 5. The short chapter about Leonardo puts the painter's work in historical perspective.

Richard Friedenthal, *Leonardo da Vinci: A Pictorial Biography.* Trans. Margaret Shenfield. New York: Viking Press, 1959. A biography of Leonardo, filled with many black-and-white reproductions of the author's work, along with a few color plates.

Ivor B. Hart, *The Mechanical Investigations of Leonardo da Vinci.* Berkeley and Los Angeles: University of California Press, 1963. Hart, the author of several books about mechanics, explores the scientific value of Leonardo's investigations and inventions.

———, *The World of Leonardo da Vinci: Man of Science, Engineer, and Dreamer of Flight.* Fairfield, NJ: Augustus M. Kelley, 1977. This biography focuses on Leonardo's engineering genius in a thorough manner, detailing the concepts and the actual physics behind his inventions.

Frederick Hartt, *History of Italian Renaissance Art.* New York: Harry N. Abrams, 1969. This book explores the painting, sculpture, and architecture of the Italian Renaissance. The author is an esteemed art historian who has written several books on Renaissance painting and painters.

Ludwig H. Heydenreich, *Leonardo da Vinci.* 2 vols. New York: Macmillan, 1928. Volume 1 of this book is divided into sections titled Art as Science and Science as Art, which explore how

Leonardo combined the two schools of thought. The chapters explore Leonardo's visionary writings concerning painting, sculpture, the science of painting, mathematics, optics, anatomy, and so on. Volume 2 is composed entirely of plates depicting Leonardo's drawings, paintings, writings, and more.

Richard W. Hibler, *Life and Learning in Ancient Athens*. New York: University Press of America, 1988. This short work focuses on life in ancient Athens and contains some of the philosophies on which the humanists and Leonardo based their framework of knowledge.

Leonardo da Vinci, *Paragone*. Ed. and trans. Irma A. Richter. London: Oxford University Press, 1949. *Paragone* or "comparison of the arts" is the modern title given to this treatise on painting by Leonardo, which is now in the Vatican library. This was the only book published under Leonardo's name until the nineteenth century. It foreshadowed the beginnings of comparative art criticism.

Edward McCurdy, *The Mind of Leonardo da Vinci*. New York: Dodd, Mead, 1948. McCurdy made a study of Leonardo's manuscripts and notes to present a biographical survey of Leonardo in vivid detail, while exploring the influences that shaped the artist's mind.

Bernard S. Myers, *Art and Civilization*. New York: McGraw-Hill, 1957. This book is a stimulating history of world painting, sculpture, and architecture from primitive to modern times. The chapter on fifteenth-century Italy mentions Leonardo and clarifies his exalted place in the period known as the Renaissance.

Walter Pater, *The Renaissance*. New York: Macmillan, 1899. This book was first published in 1873. The author is one of the most respected nineteenth-century biographers of Leonardo, and an expert on the Florentine Renaissance in which the artist played such a large part.

Robert Payne, *Leonardo*. New York: Doubleday, 1978. A modern biography of Leonardo that portrays the artist not only as a giant of his time but as a real person with flaws, hopes, and dreams. The author is a well-known biographer who has written about famous figures such as Stalin and Gandhi.

Ladislao Reti, ed., *The Unknown Leonardo*. Maidenhead, England: McGraw-Hill, 1974. This book, based on Leonardo's so-called *Madrid Codices*, is full of insightful writing and large, color reproductions of the artist's work.

Ariane Ruskin, *Art of the High Renaissance*. New York: McGraw-Hill, 1968. This scholarly book explores the art of the High Renaissance and Leonardo's place within it.

Raymond S. Stites, *The Sublimations of Leonardo da Vinci*. Washington, DC: Smithsonian Institution Press, 1970. A book that analyzes Leonardo's personality and previous, older

biographies of the painter. This large work contains page after page of reproductions taken directly from Leonardo's precious codices.

Rachel Annand Taylor, *Leonardo the Florentine*. New York: Harper & Brothers, 1928. A biography on Leonardo that ties his work in with humanism, Greek philosophy, and other studies. The author was also a well-known poet and this book is written in an excessively flowery language that amuses but often bewilders today's readers.

Giorgio Vasari, *Lives of Painters, Sculptors and Architects*. London: J. M. Dent & Sons, 1963. Vasari, who lived from 1511 to 1574, is the first biographer of Leonardo da Vinci. Although he did not actually know the painter, he interviewed those who did for the short entry about Leonardo.

Websites

The Institute and Museum of the History of Science in Florence, Italy (http://galileo.imss.firenze.it/news/mostra/6/e62.html). This website is the starting point for the pages containing Leonardo's *Codex Atlanticus, Manuscript B,* and *Madrid Manuscript II.*

ITN Online (http://www.itnelection.co.uk/World/world19990528/052806w.htm). Britain's leading multimedia news site. Has commentary as well as before-and-after pictures of the restoration of the *Last Supper.*

OCAIW: Orazio Centaro's Art Images on the Web (http://www.ocaiw.com/leonardo.htm). This site, run by Italian painter Orazio Centaro, contains hundreds of pictures, drawings, sketches, and plans by Leonardo da Vinci that may be downloaded to any personal computer.

Index

Picture Credits

Cover photo: North Wind Picture Archives

Art Resource, NY, 103

Corbis/James L. Amos, 15, 19, 44

Corbis/Bettmann, 74, 97

Corbis/Gianni Dagli Orti, 20

Corbis/David Lees, 16

Corbis/Ted Spiegel, 62

Corbis/Sandro Vannini, 50

Corbis/Adam Woolfitt, 75

Giraudon/Art Resource, NY, 86

Erich Lessing/Art Resource, NY, 30

Library of Congress, 88

Planet Art, 10, 29, 32, 33, 43, 47, 48, 51, 61, 76, 77, 80, 81, 83, 93, 94, 99

Prints Old & Rare, 11

North Wind Pictures Archives, 12, 23, 27, 34, 37, 49, 57, 59, 65, 71, 73, 91, 100

Scala/Art Resource, NY, 24, 55, 56, 69, 85, 87, 90

Stock Montage, Inc., 18, 41, 101

About the Authors

Stuart A. Kallen is the author of more than 145 nonfiction books for children and young adults. He has written on topics ranging from the theory of relativity to rock-and-roll history to life on the American frontier. In addition, Mr. Kallen has written award-winning children's videos and television scripts. In his spare time, Stuart A. Kallen is a singer/songwriter/guitarist in San Diego, California.

Patti Marlene Boekhoff is a graduate of the Minneapolis College of Art and Design and a professional artist who has co-created several children's books on the subject of ecology, and illustrated many book covers. She has exhibited in museums, created public murals and theatrical scenics, and designed a bridge with a master planning committee. In her spare time, she writes poetry and studies herbal medicine. Since childhood, she has written in the reverse left-handed script employed by Leonardo.